About this book

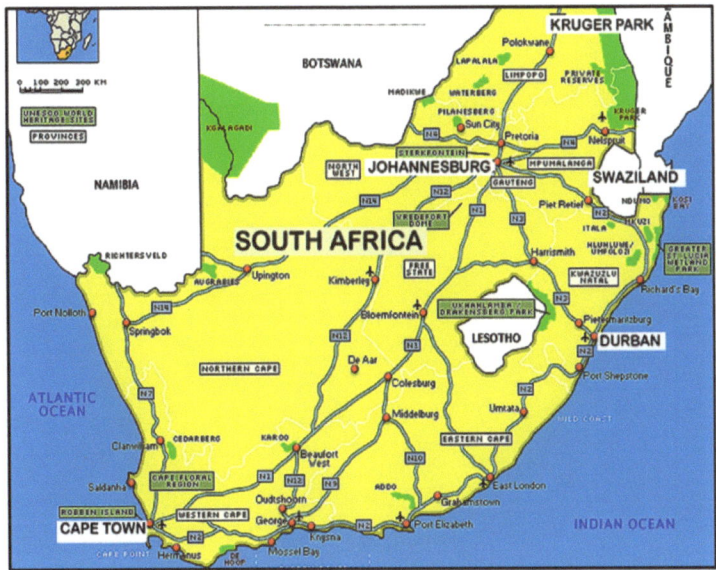

South Africa is a large country, including landlocked and close neighboring nations. It has lots of history, full of culture and diversity, and has an abundance of interesting attractions. This book provides images of some of the more popular ones and includes bits and pieces of some of its turbulent history. Taking the tram to the top of Table Mountain for an awesome overview of Cape Town creates an impressive and lasting memory. Seeing the graceful animals in the wild and in their natural habitats was an exhilarating and highlight experience. Experiencing Victoria Falls, viewing the beautiful landscapes of the countryside, and taking in views along the coastal highway was equally rewarding.

Enjoy
-jlGill

Table Mountain

The Devil's Peak

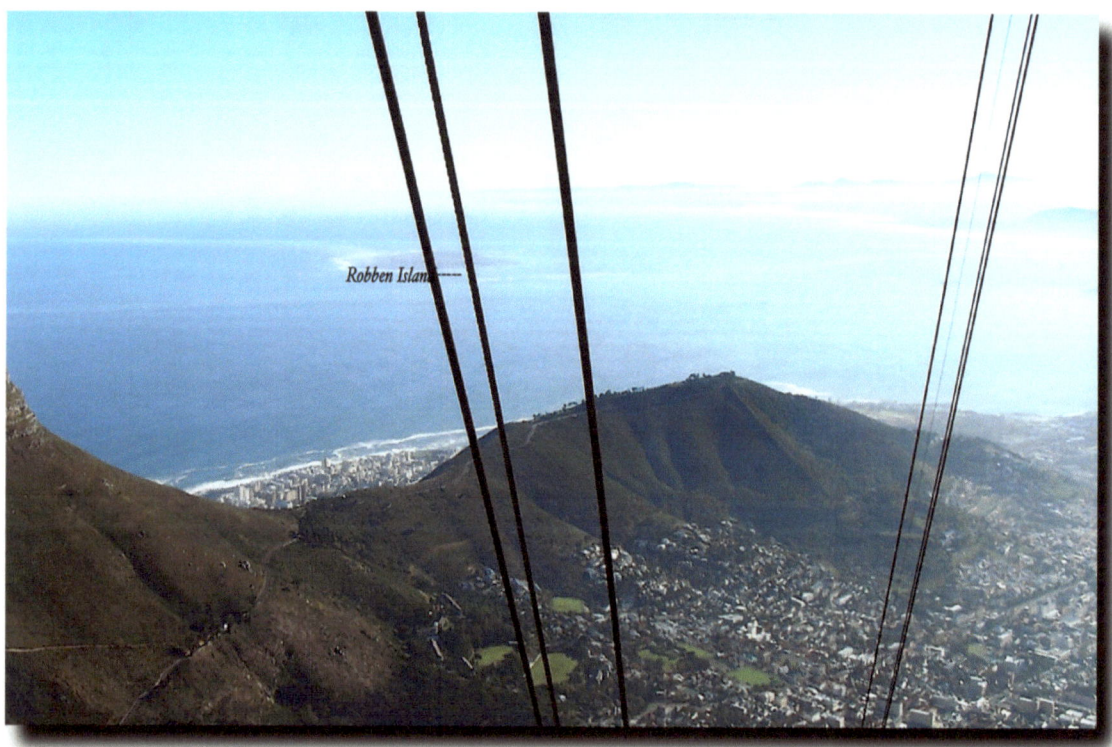

Taking the Aerial Tram to the top of Table Mountain

From inside the Tram, as well as the top of the mountain, Robben Island can be seen in the background.

Aerial tram landing dock and a landscape view on top of Table Mountain

"Devil's peak" is flanked to the right of Table Mountain. To the left sits "The Lions Head" (Photo below)

Views of Cape Town Beach (above) and "Signal Hill" (below) from the top of Table Mtn.

Down on Cape Town Beach, the mountain heads of the 12 desciples is seen in the background.

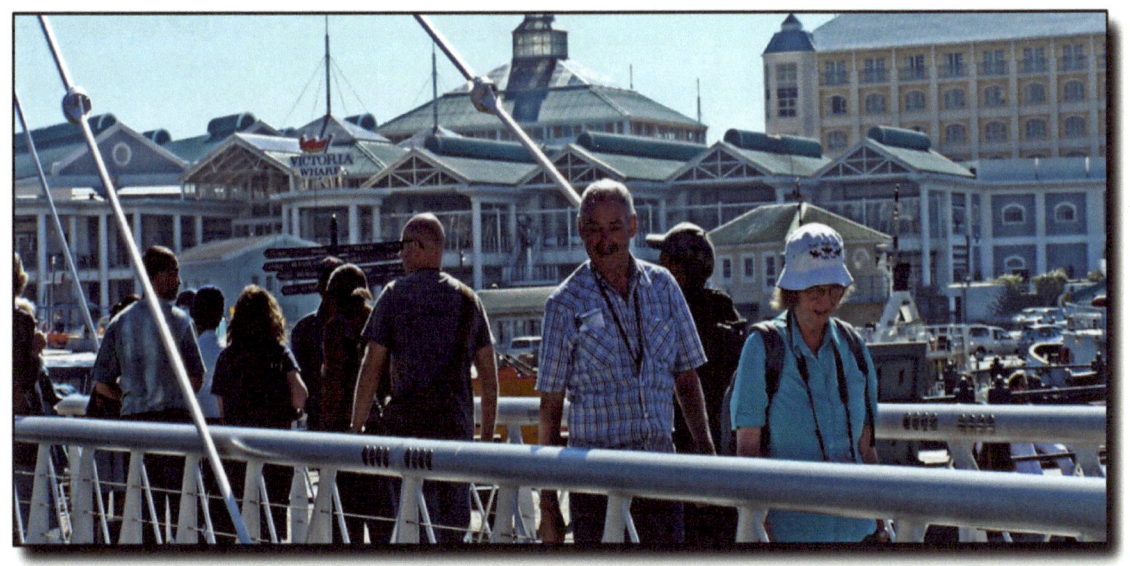
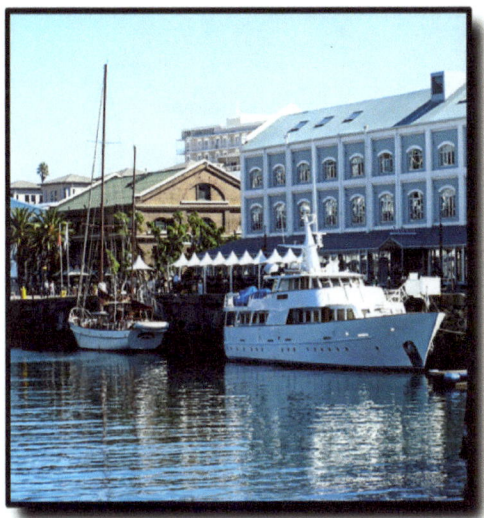

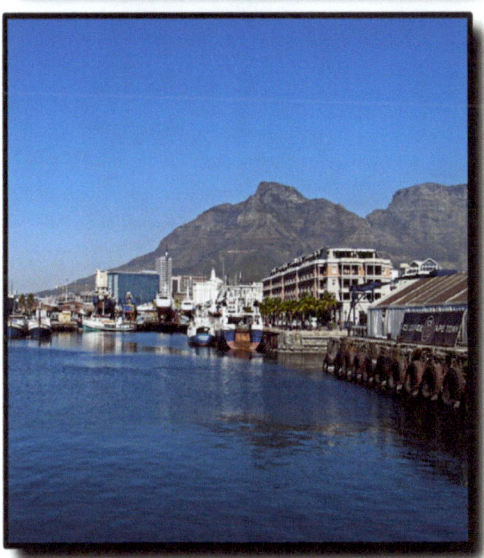

Lots of activities and restaurants on Cape Town Wharf

Statues in Nobel Square pay tribute to S.Africa's Peace Prize recipients, former President N. Mandela, former president F.W. de Klerk., Archbishop D. Tutu, and N.A.Luthuli.

Local band providing African music on the wharf

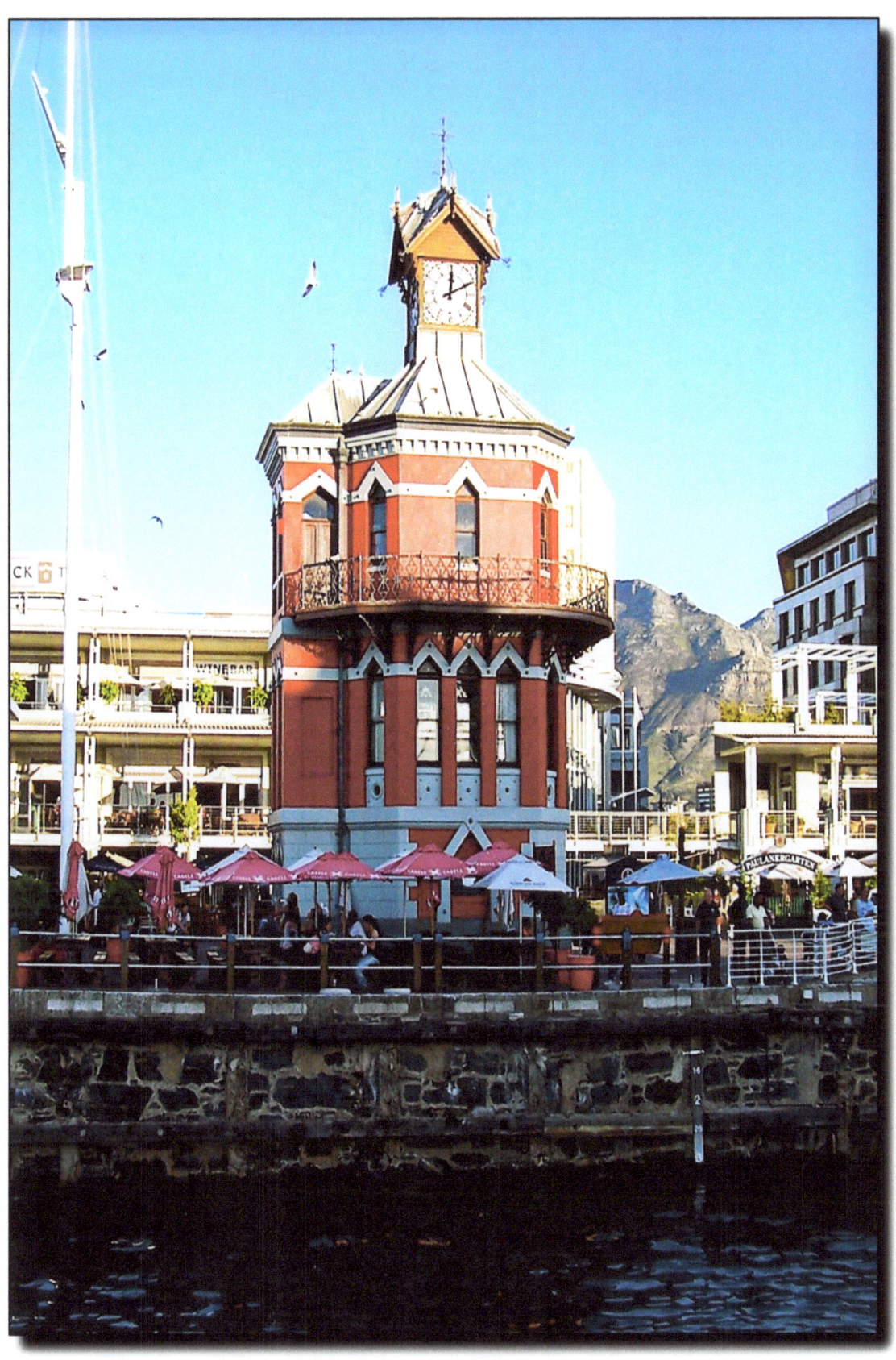
The Clock Tower is a landmark meeting place on Cape Town wharf

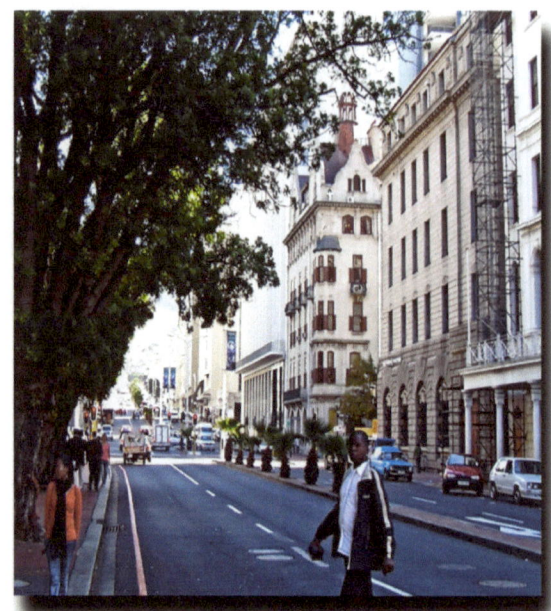

Downtown Cape Town

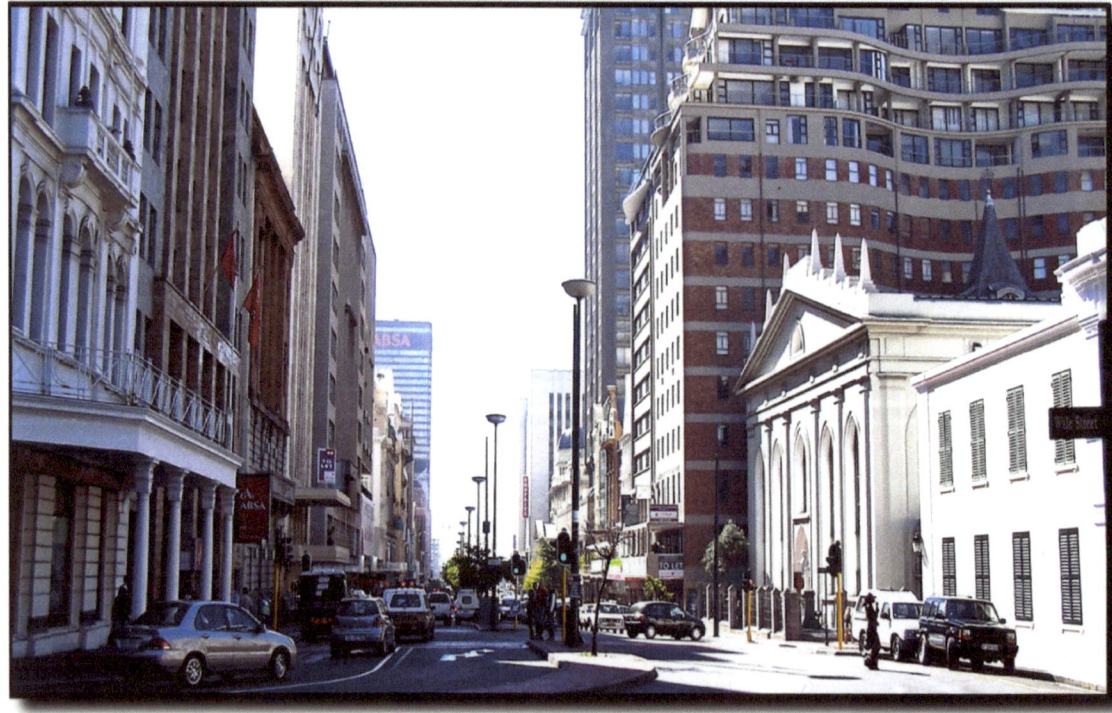

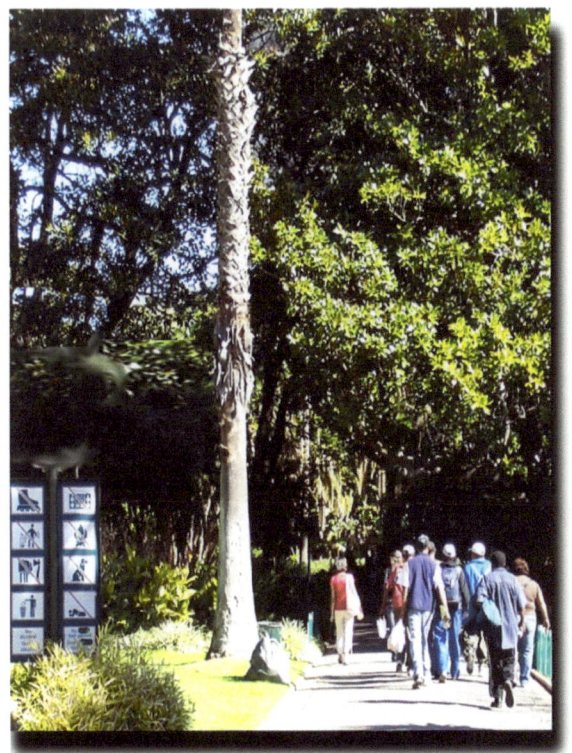
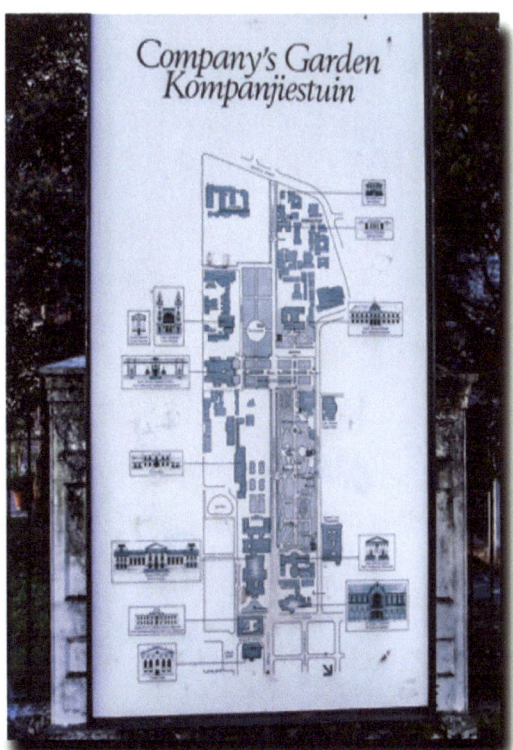
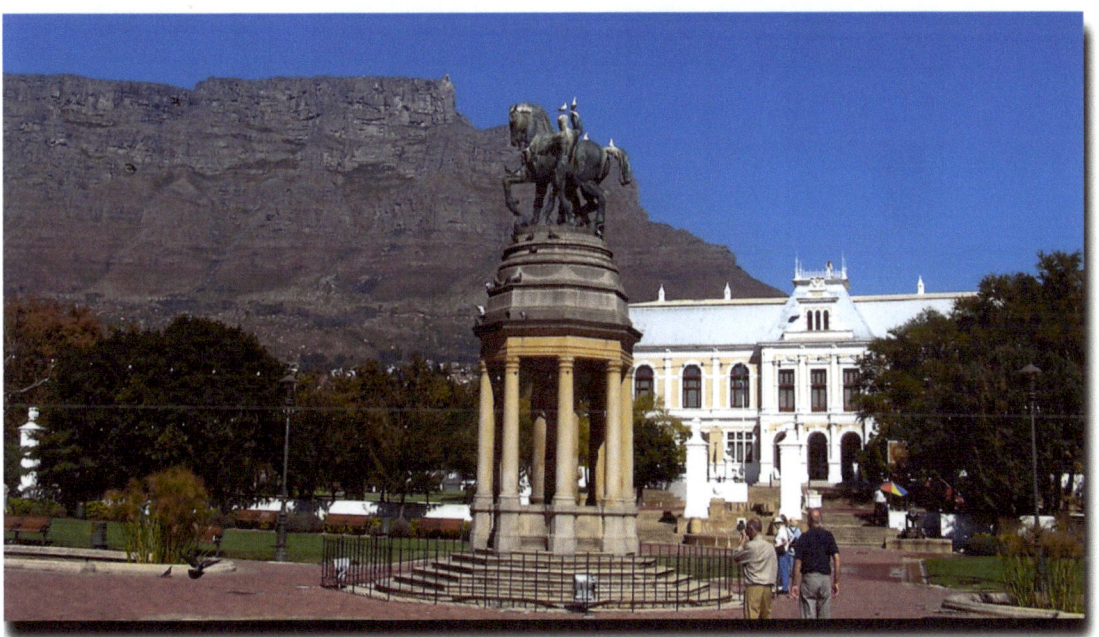

The Company's Garden is like a cultural center with many interesting attractions, museums, and exhibits. At the entry of the Garden is the Slave Lodge, now a culture museum. Built in 1679, it initially served to house the slaves of the Dutch East India Co. bringing spices in through Cape of Good Hope. Harsh treatment the enslaved experienced gives the building a decidedly eerie air that continues to linger throughout the passages and dungeons of the lodge.

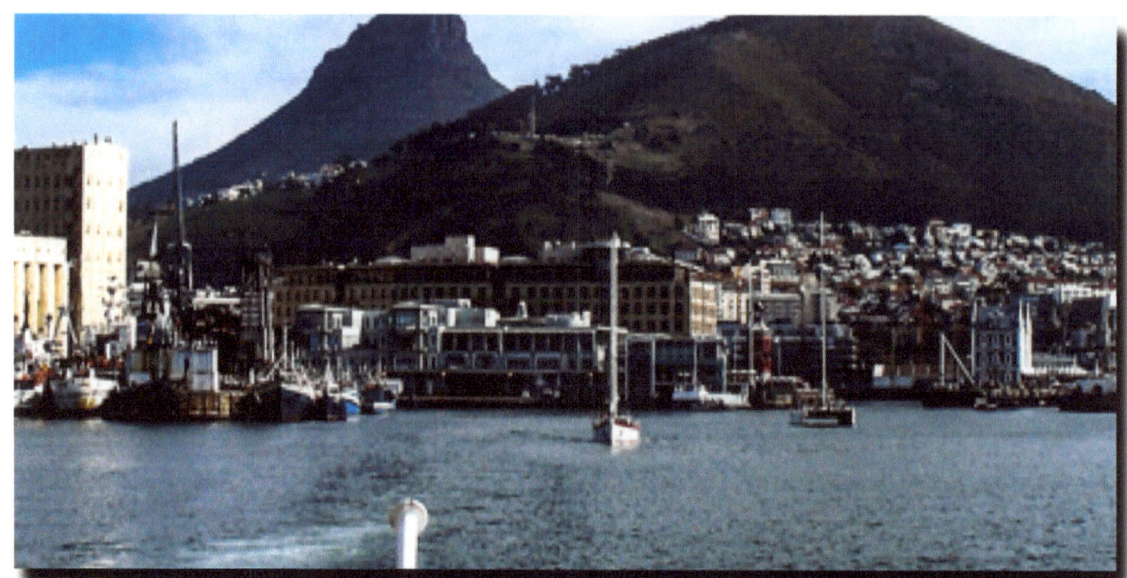

Views of Cape Town Wharf on the way out to Robben island

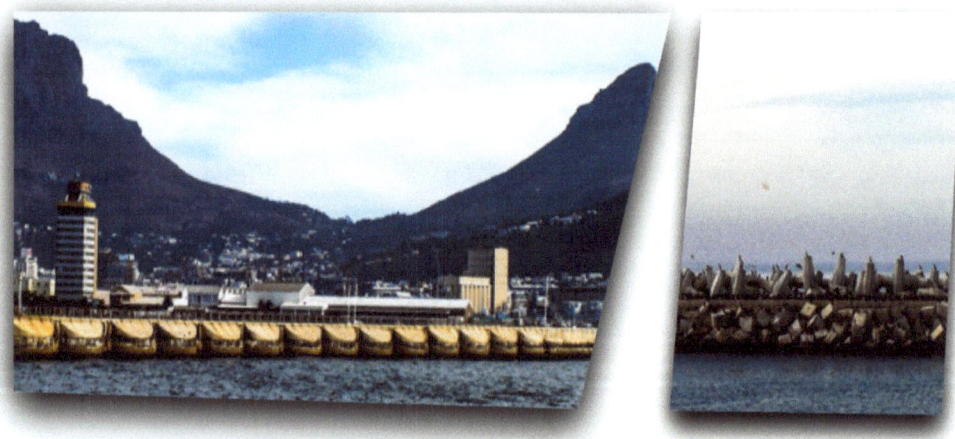

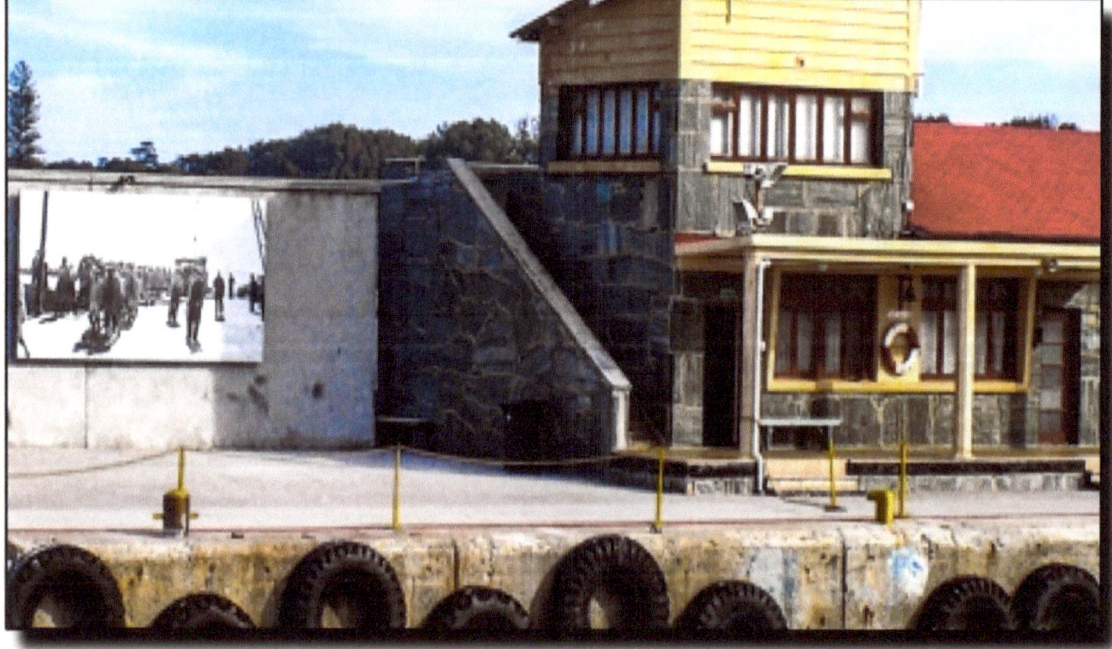

Robben Island Prison site where Nelson Mandela spent most of his 27 years in confinement serving hard labour.

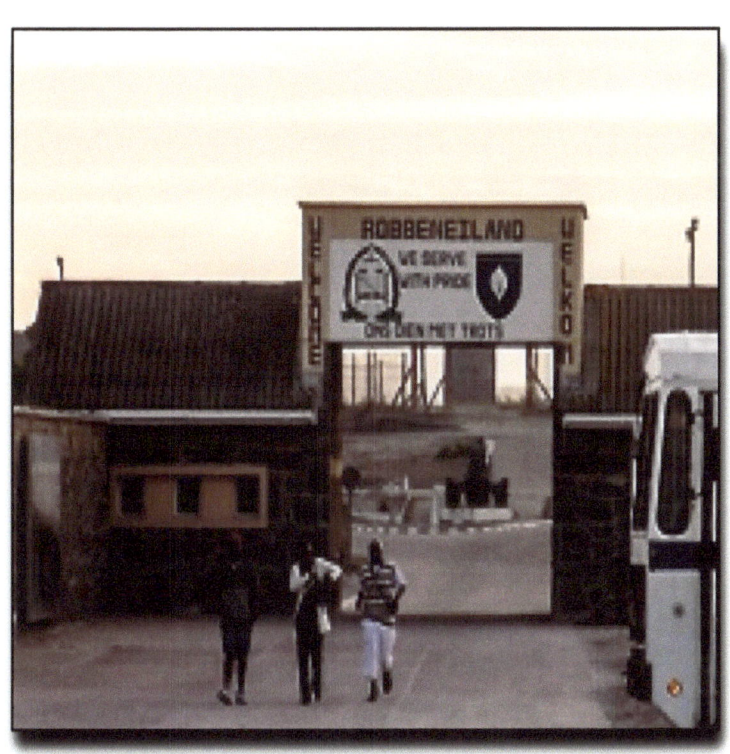
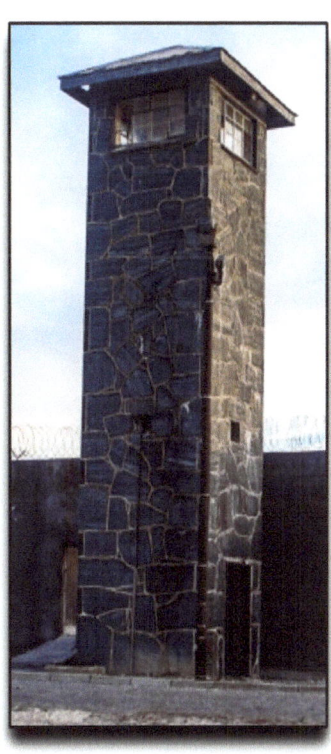

The prison Barracks. Prisoners spent their days chipping rocks into gravel, and were fed on meager rations. As posted (signs below), quality of food and proportions were determined by a prisoner's race.

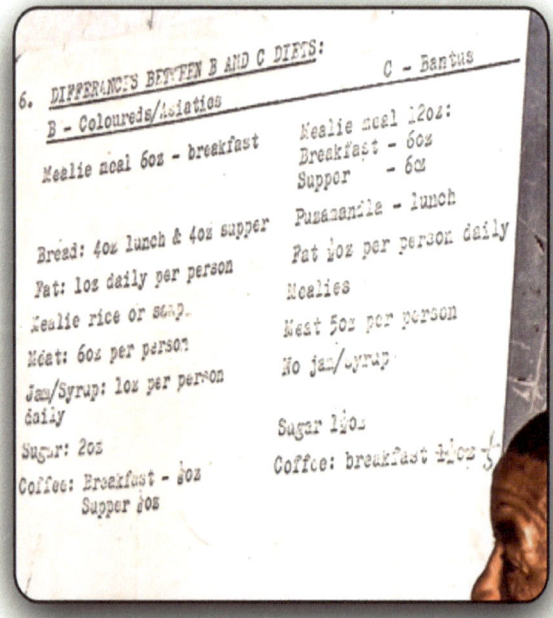

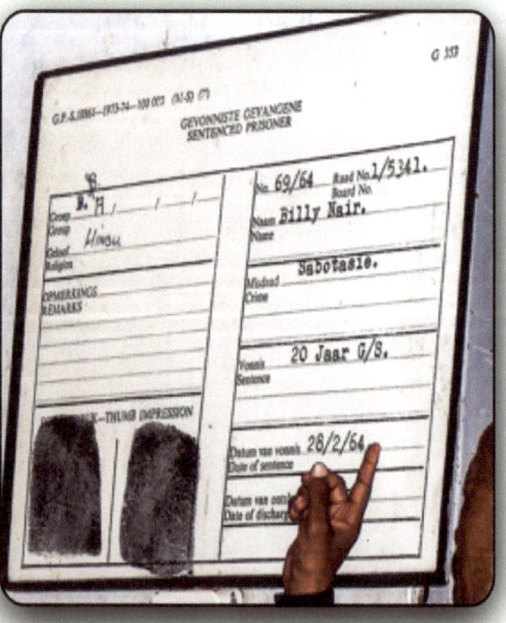

Hallway of solitary confinement prison cells

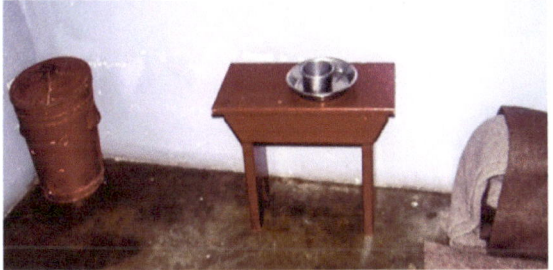

Mandela's cell in solitary confinement: no bed just a small table, pail, and sleeping mat.

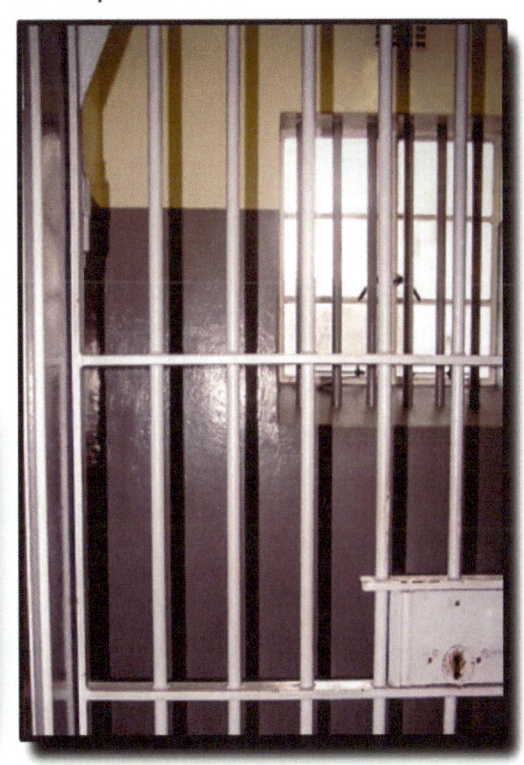

"I found solitary confinement the most forbidding aspect of prison life. There is no end and no beginning: there is only one's mind, which can begin to play tricks. Was that a dream or did it really happen? One begins to question everything."
–Nelson Mandela, from his 1994 autobiography *The Long Walk to Freedom*

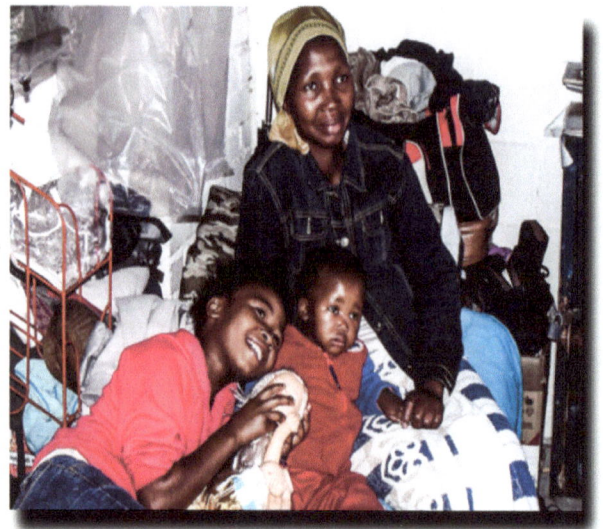
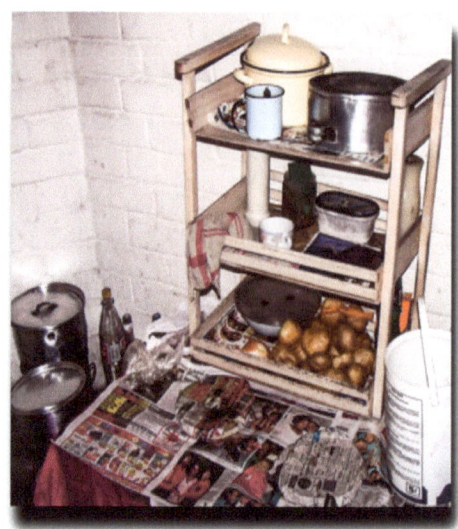
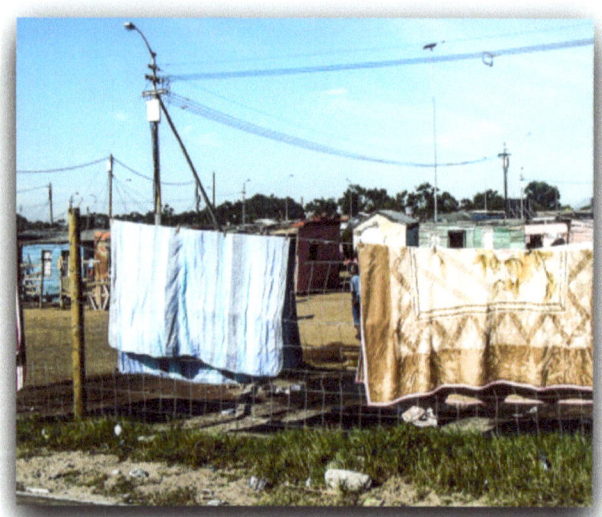

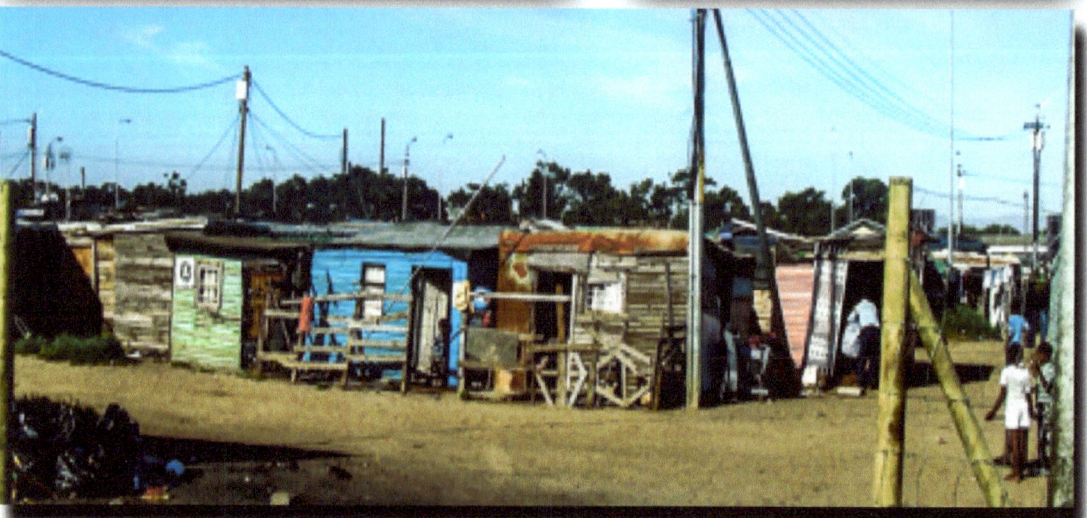

Cape Town Townships: Mostly dense makeshift shelters w/o flooring, running water, or toilets. Usually several families live in a single shelter. If they want to cook they have to dig a hole in the center of the dirt floor and build a fire.

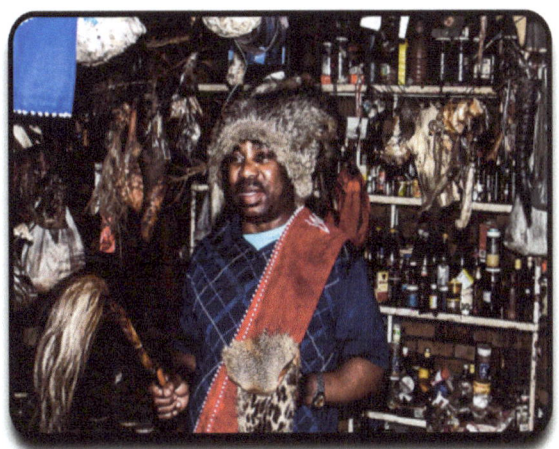

Cape Town medicine man and his collection of medical supplies. Name your illness and he has your cure.

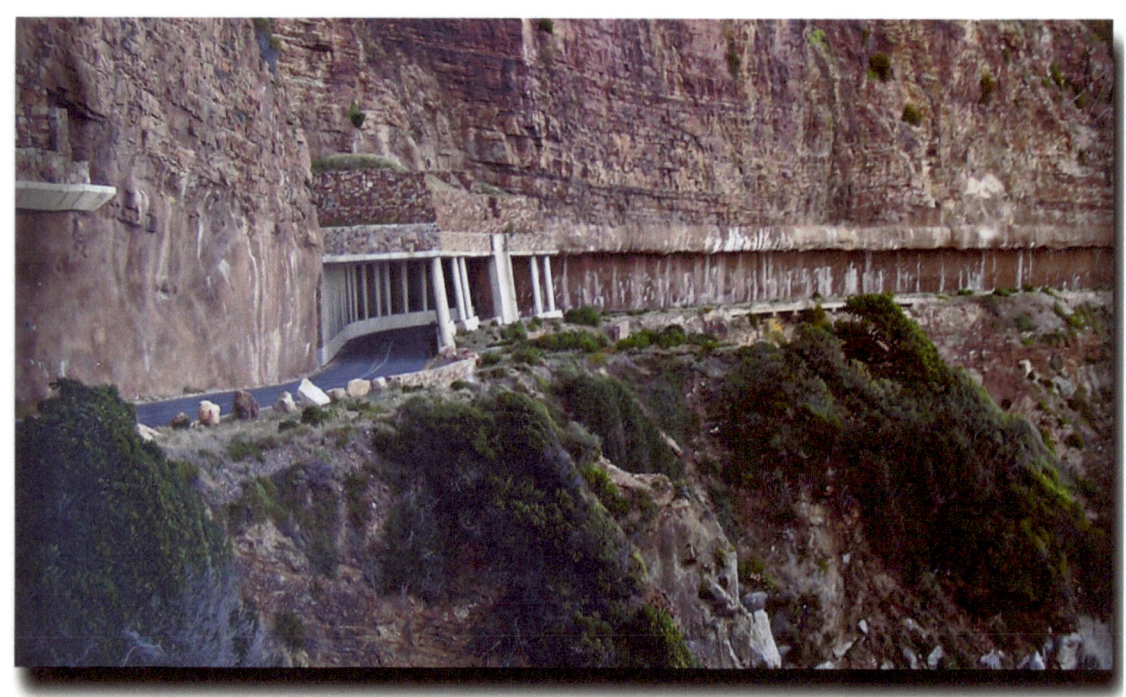

Views from Cape Town's costal highway.

Cape Town's costal views

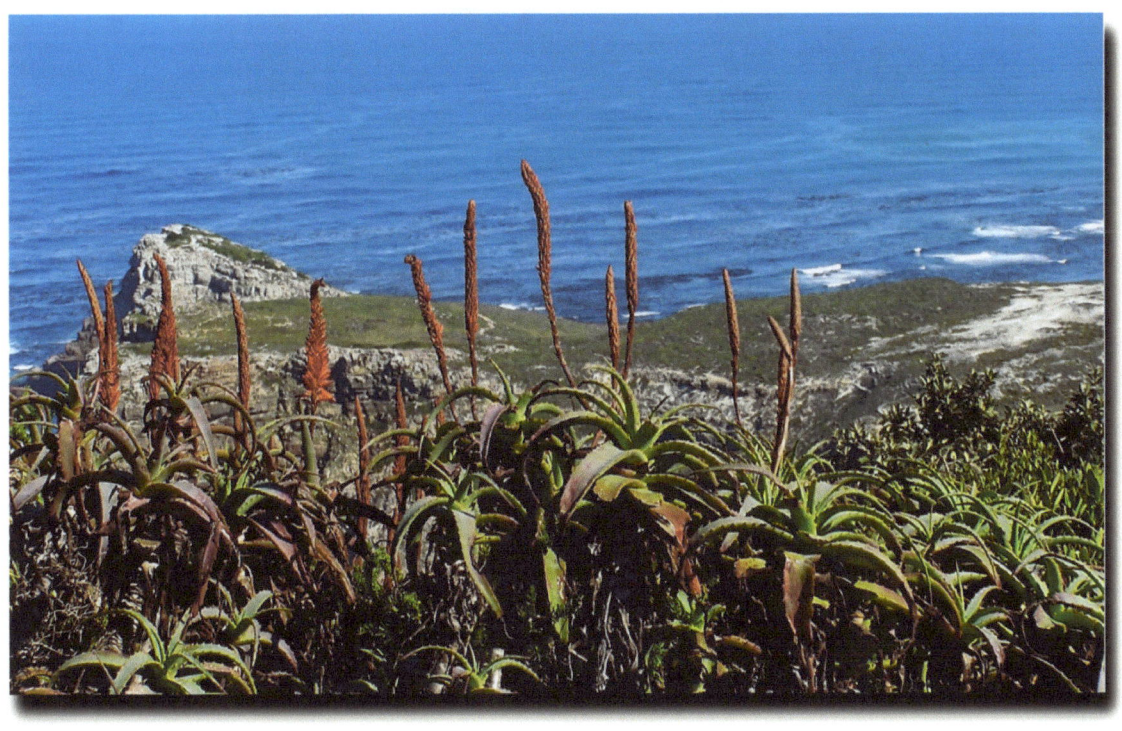

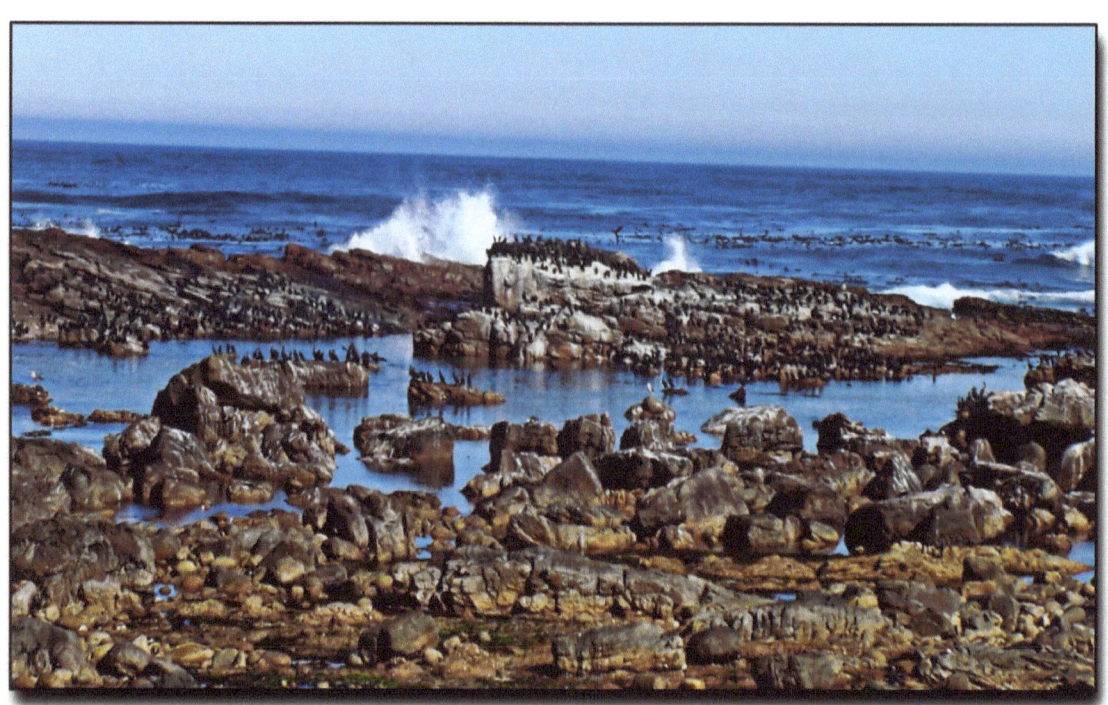

Just north of Cape of Good Hope on the peninsula is the Cape Point lighthouse.

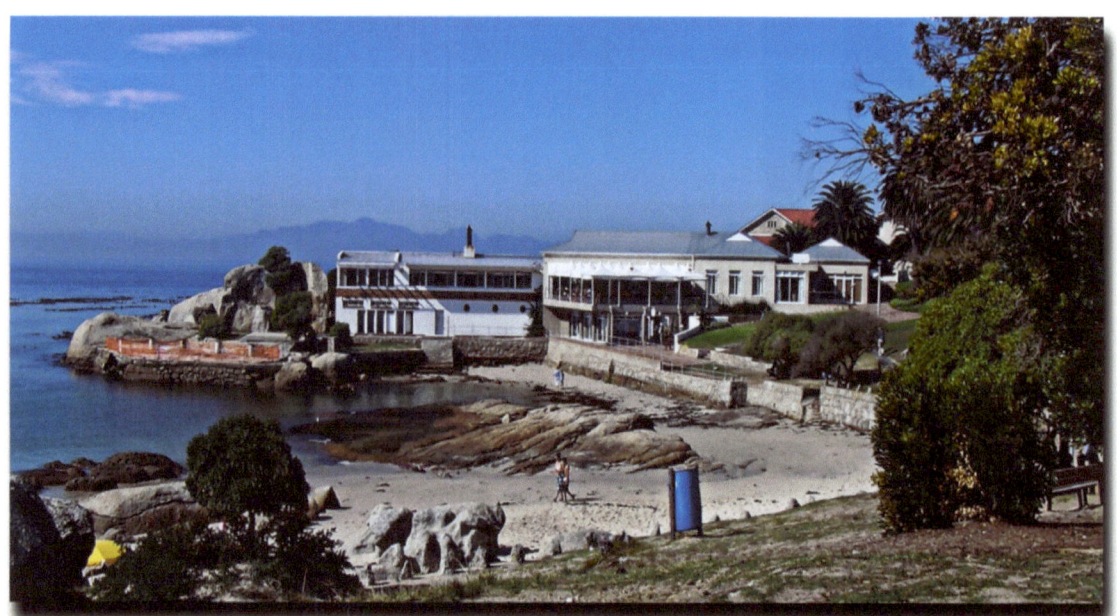

Boulder Beach Restaurant along Cape Town's coastal drive provides beautiful scenery and penguin watching while enjoying good food.

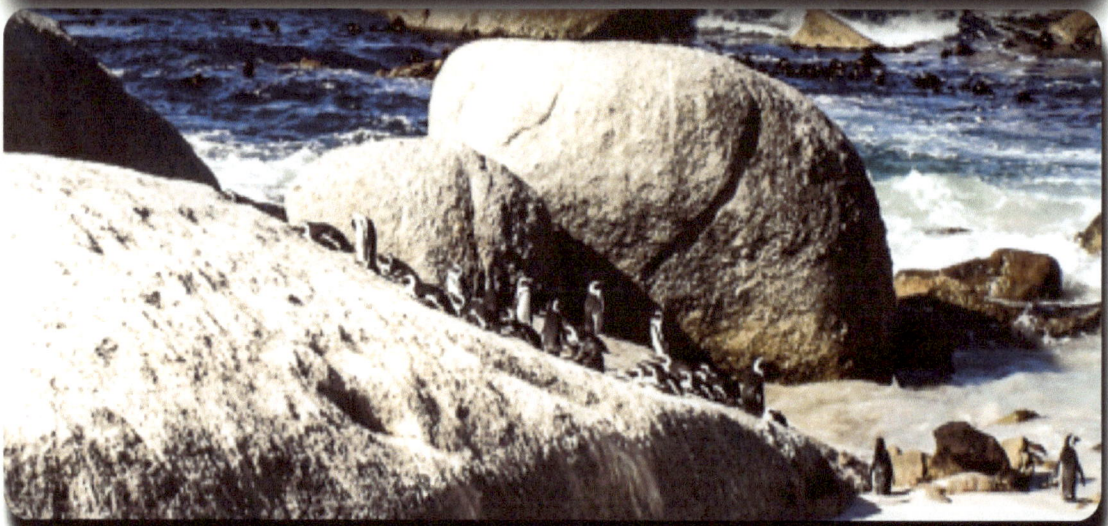

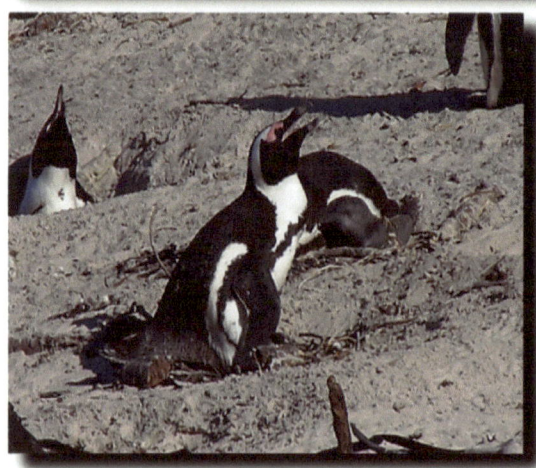

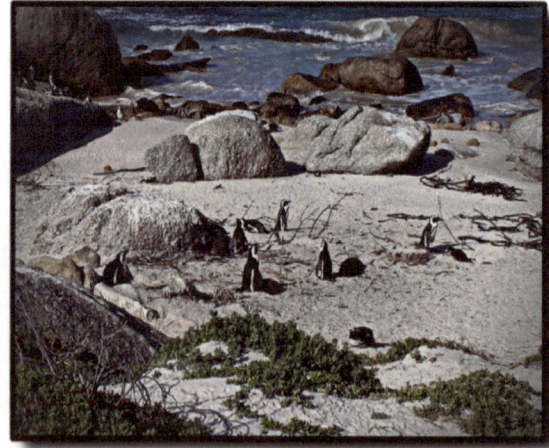

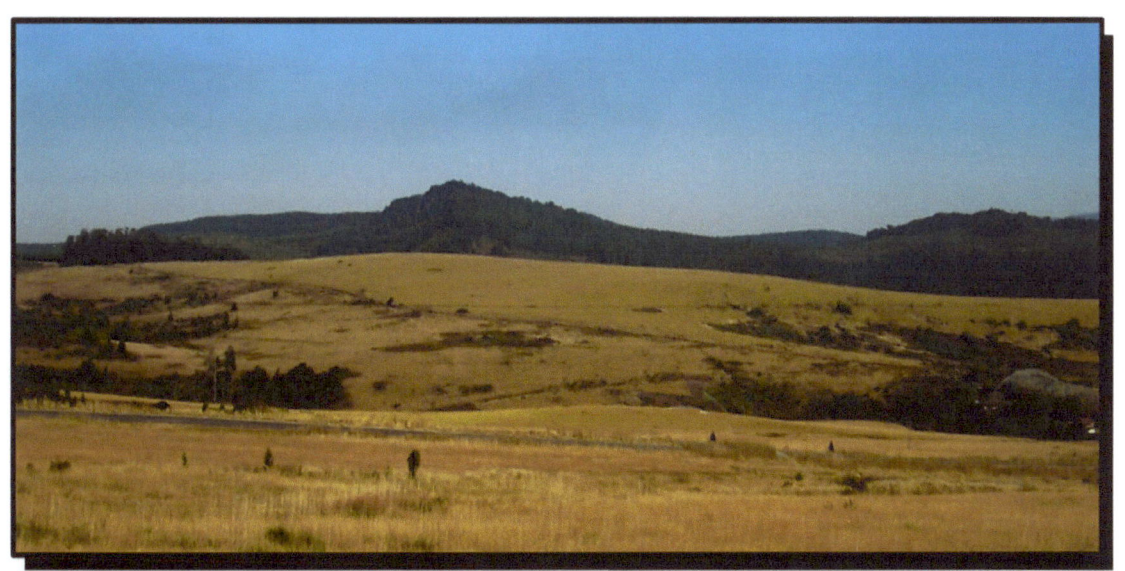

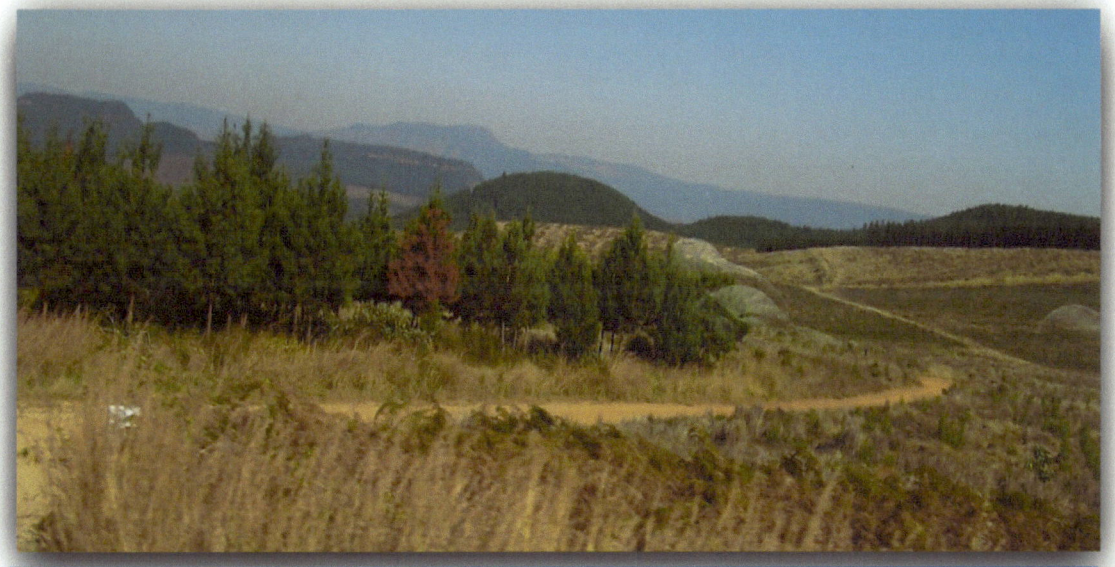

Views of South Africa's countryside

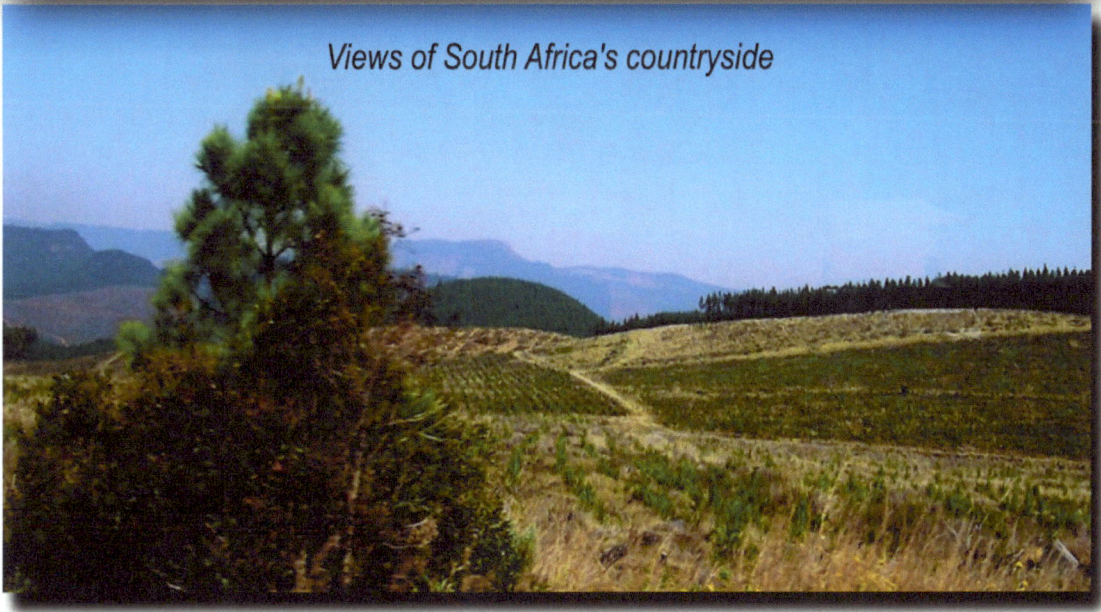

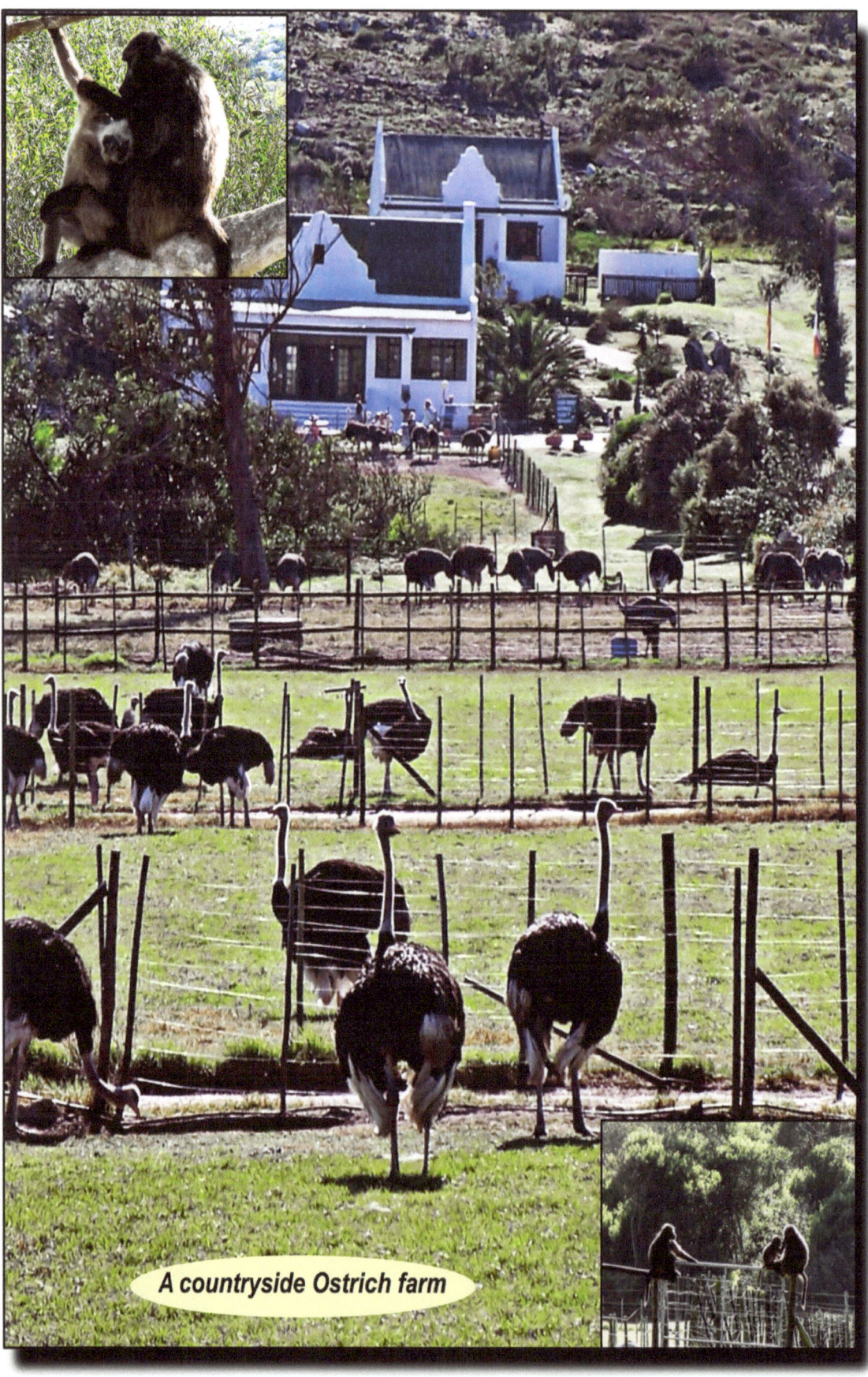

A countryside Ostrich farm

Port City of Durban

Durban is a busy and crowded city and has many beautiful hotels and resorts.

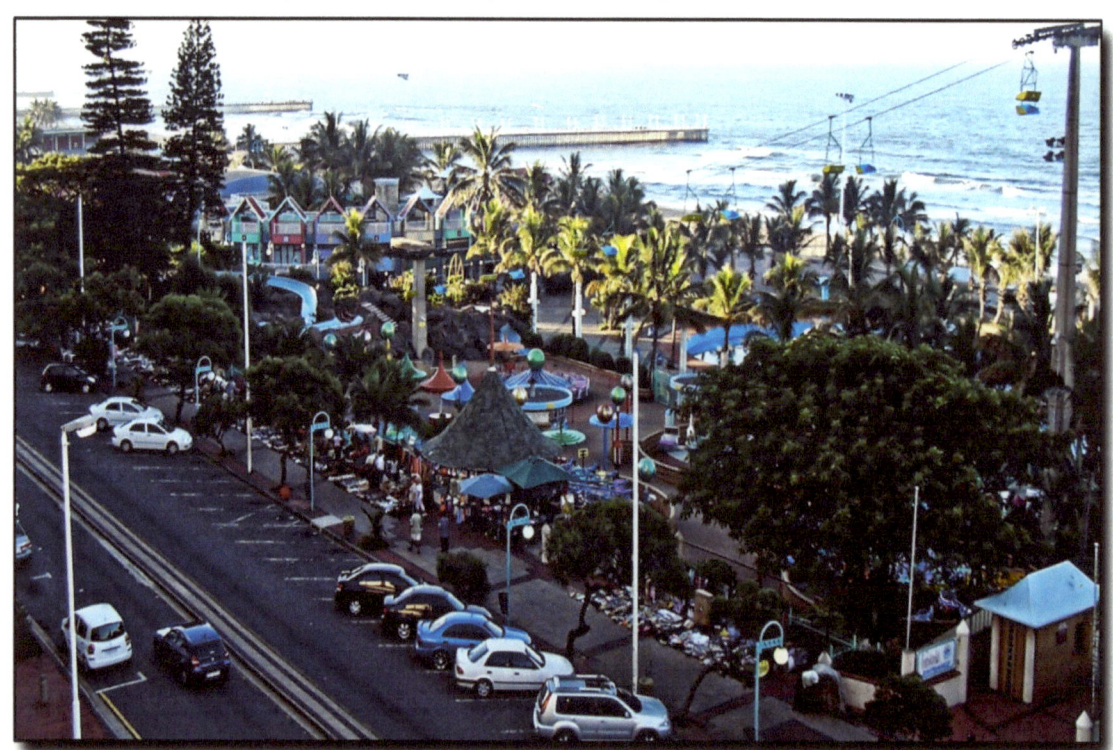

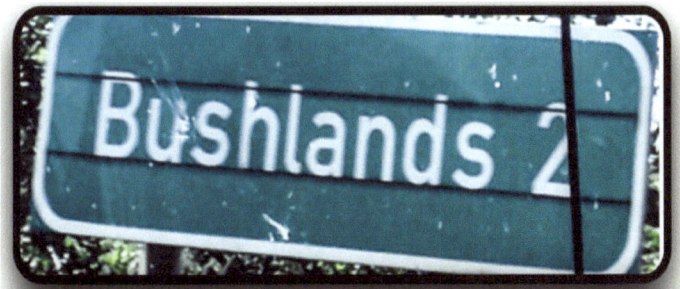

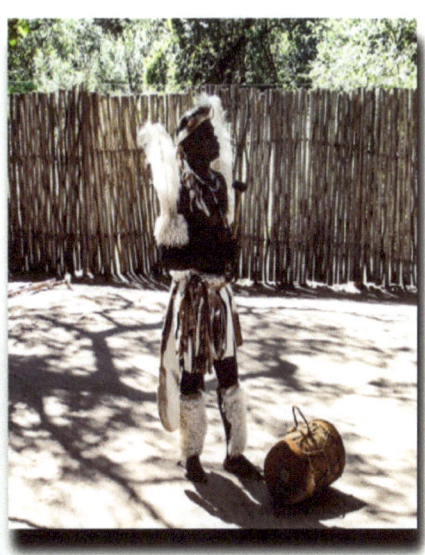

Bushlands-2 is a simulated Zulu cultural village in Zululand, a province of South Africa. It was originally built as a scenery for the movie "Shaka Zulu". The Zulu make up nearly 12% of the population and therefore S. Africa's largest single ethnic group.

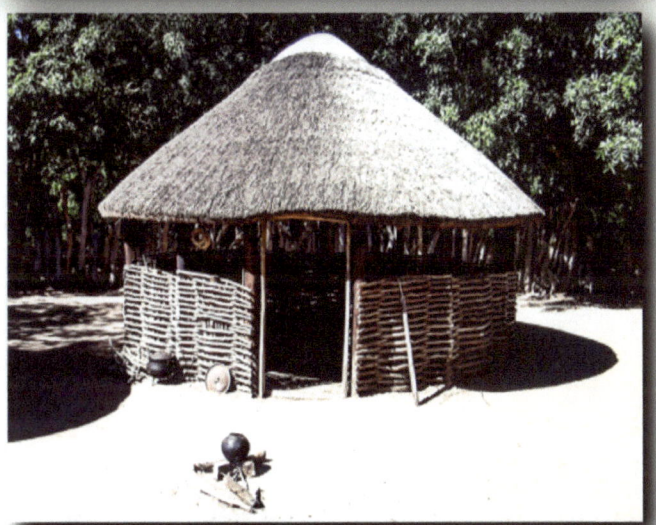

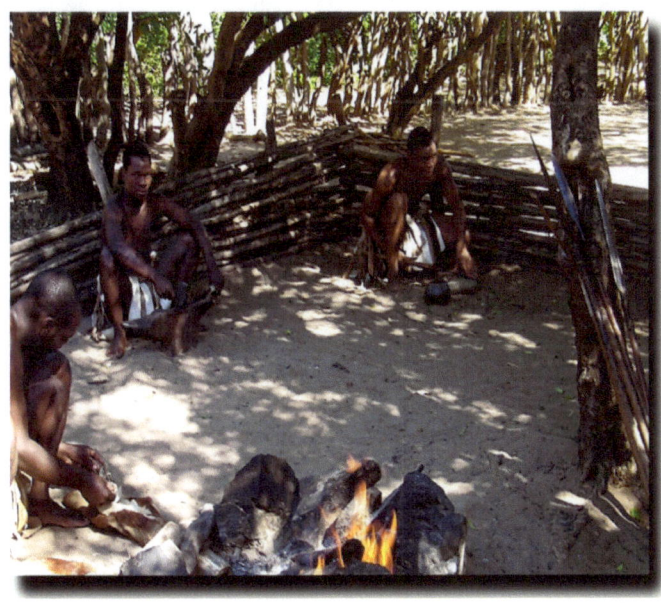

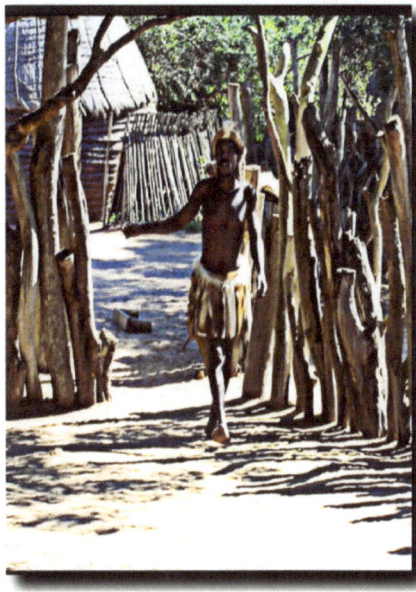

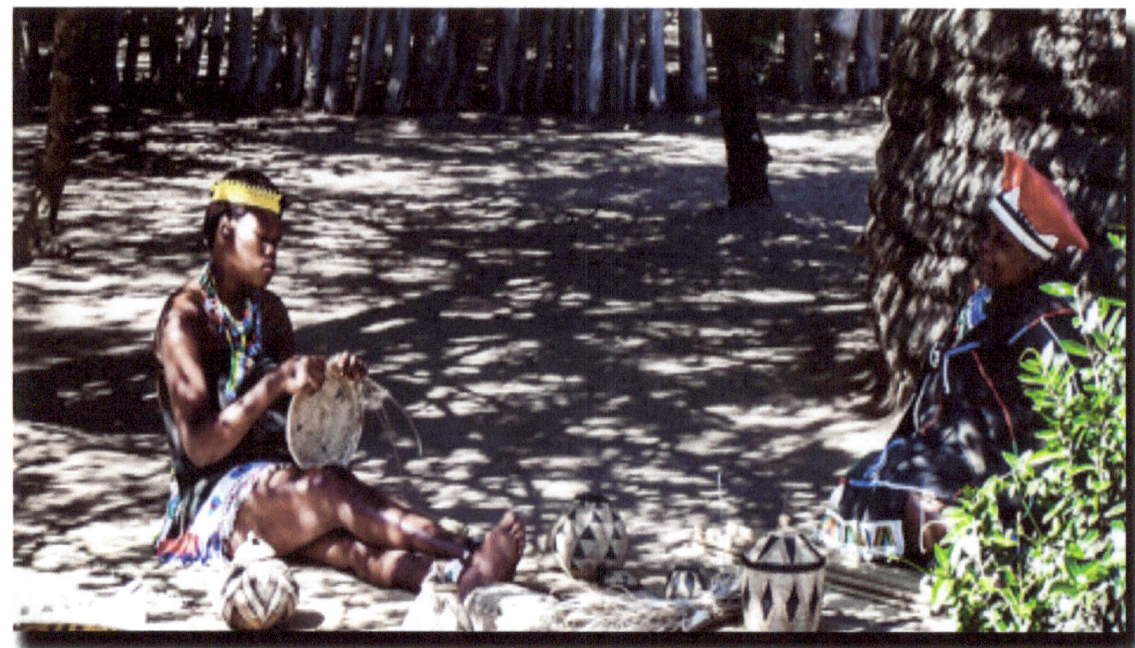

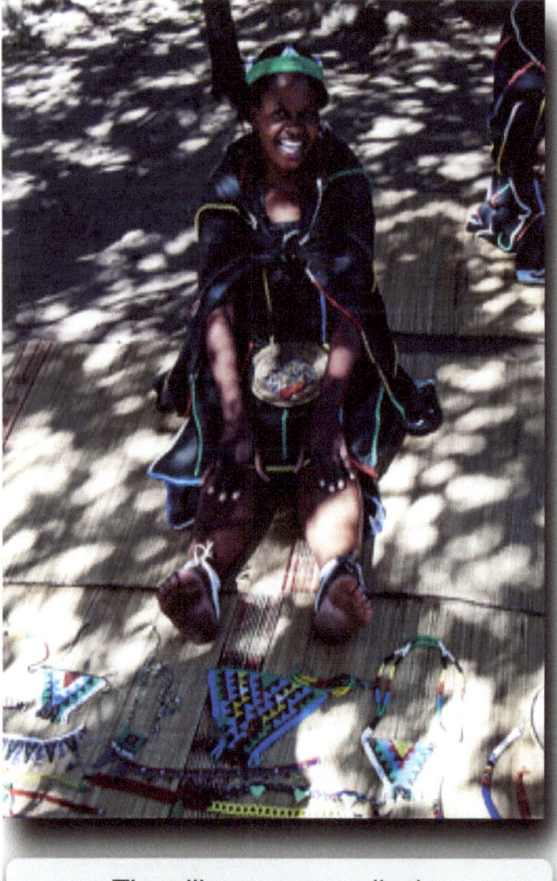

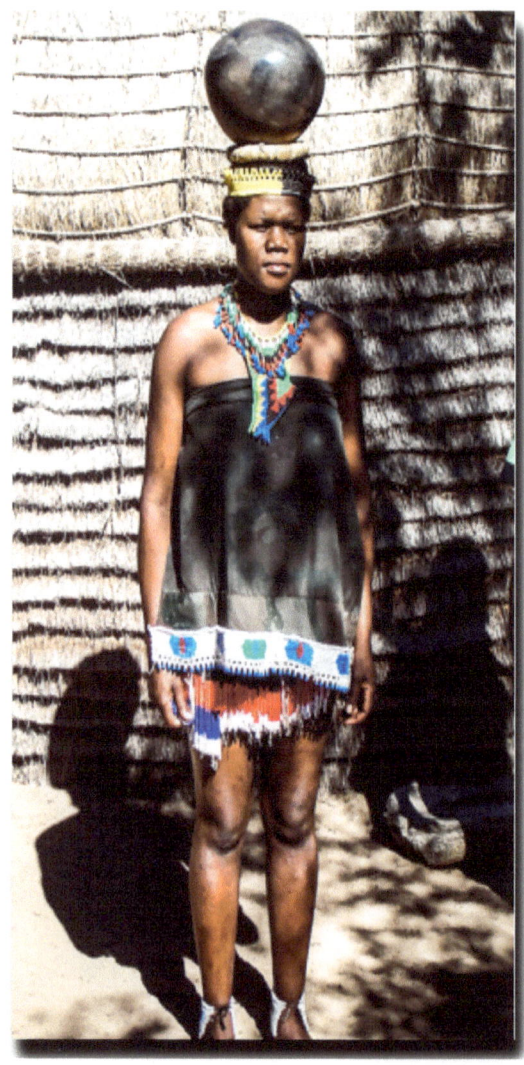

The village women display their hand made crafts and jewery.

The Zulu Medicine Man and Medicine Woman have their separate quarters.

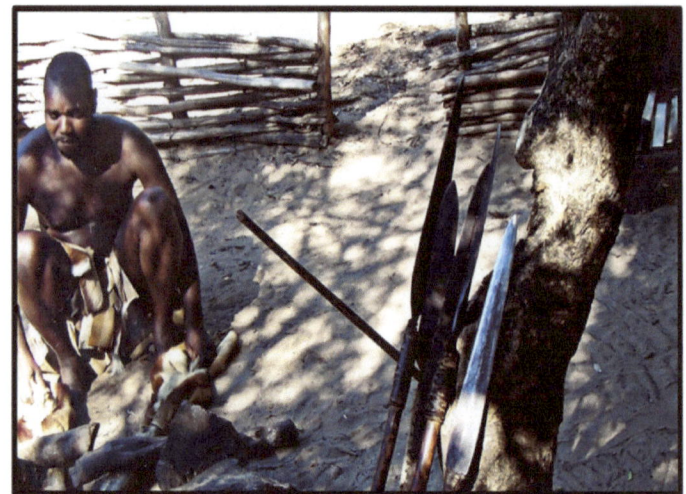
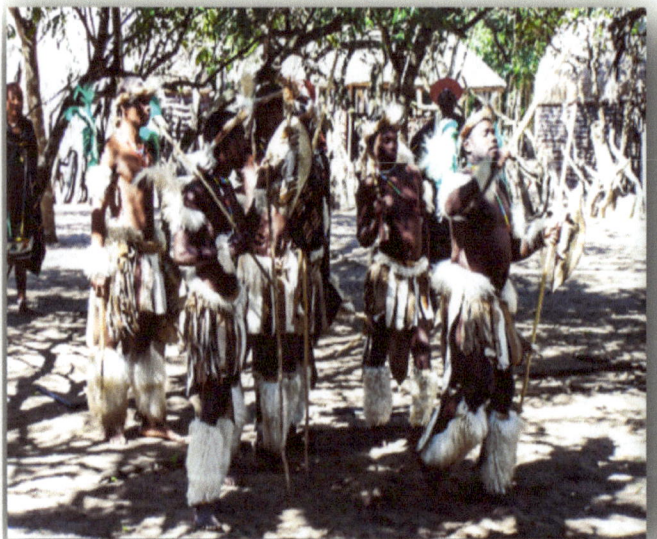
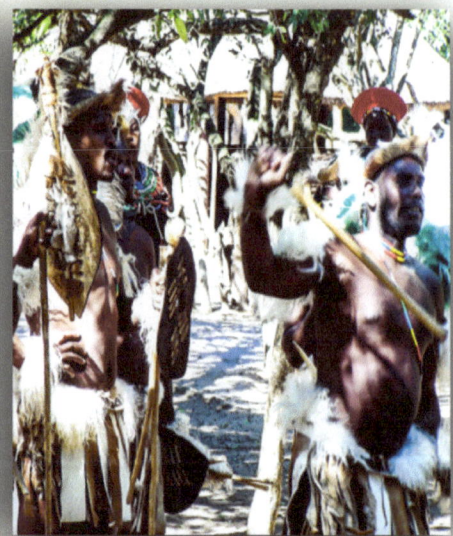

The Zulu warriors were known for their sophisticated fighting skills. Here they give a demonstration of their war dance. The women participate

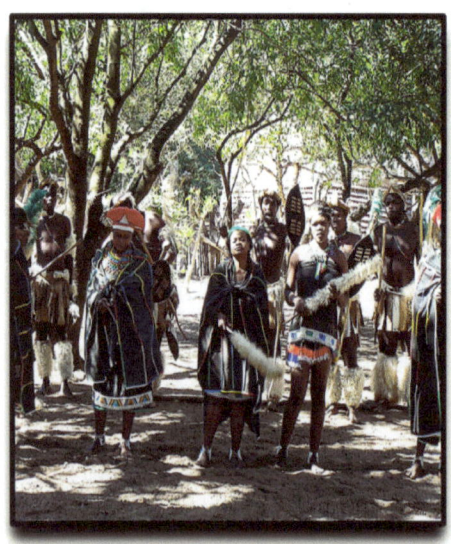
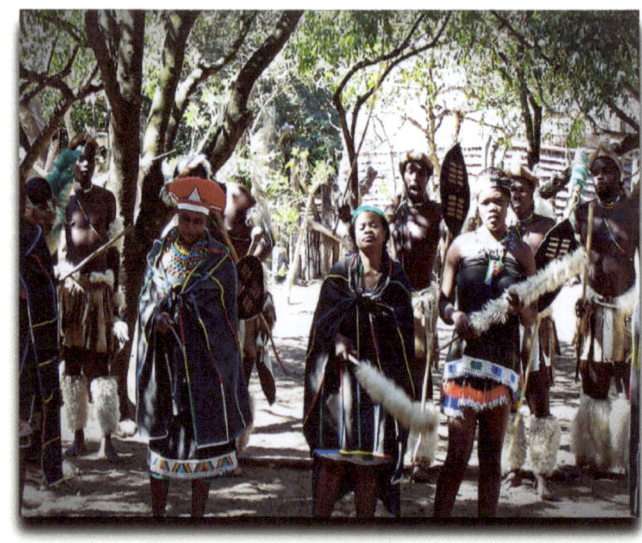

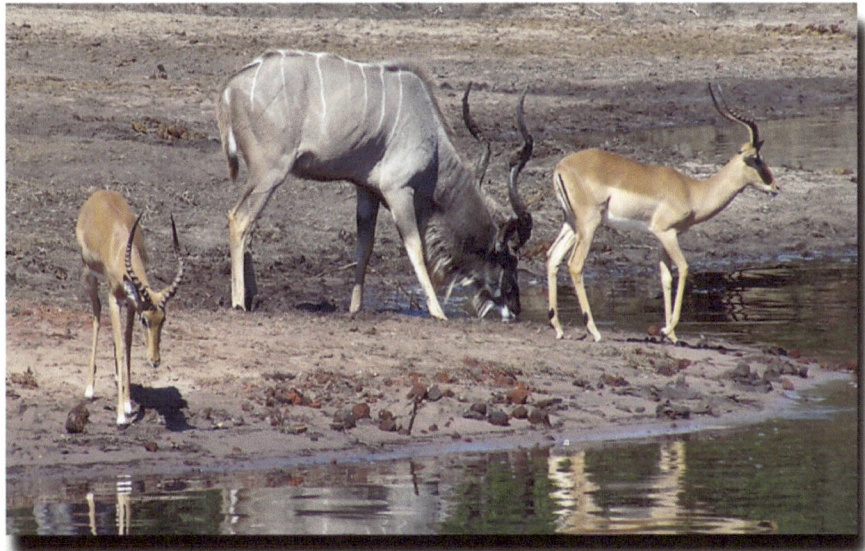
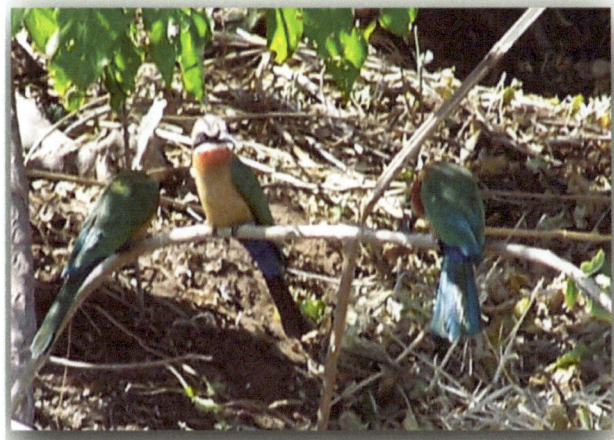
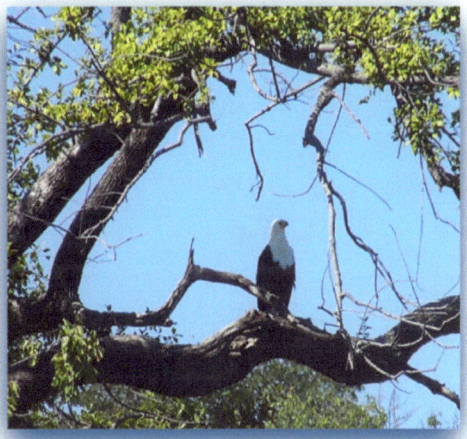

Beautiful views along the Zambizie river

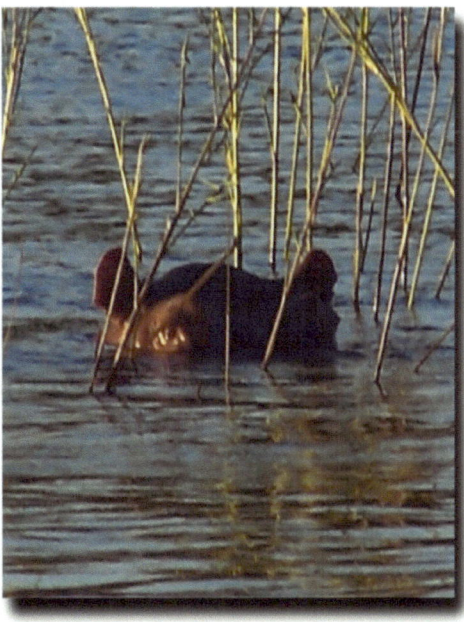

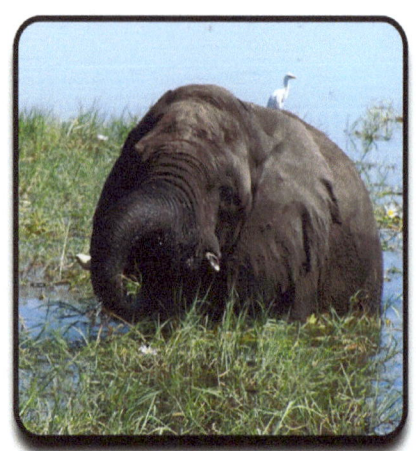
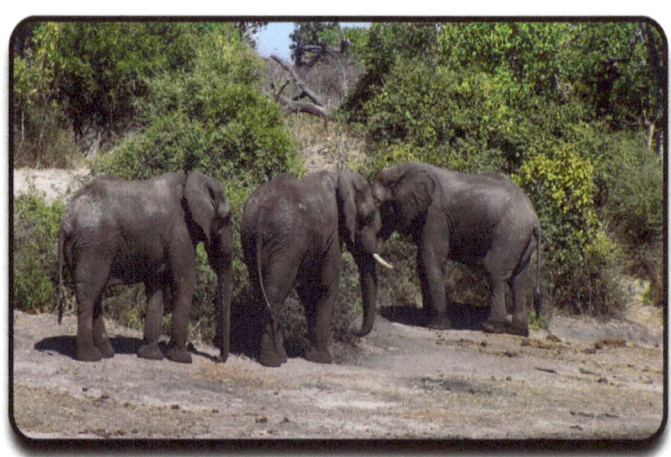
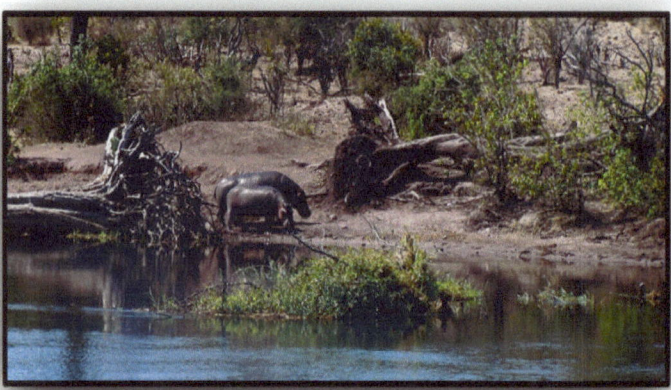
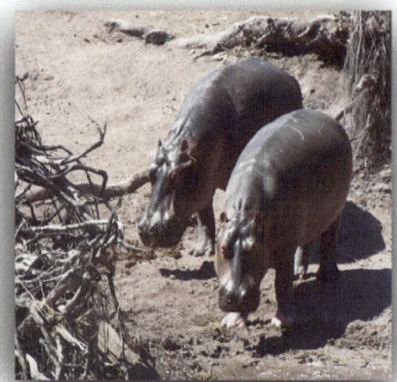

The elephants and hippopotamus stroll along the Zambizie river for water.
The giraffe and zebras are grazing in the forest in Kruger park.

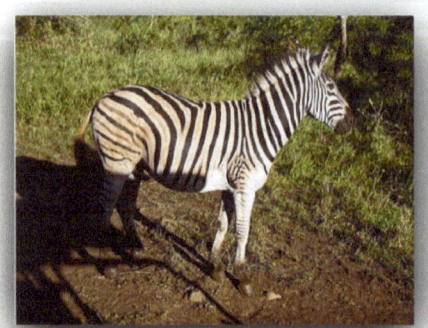
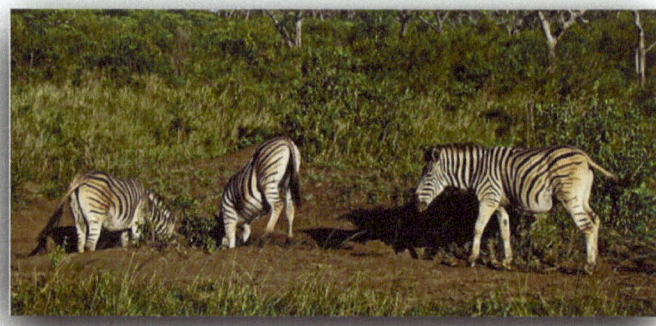
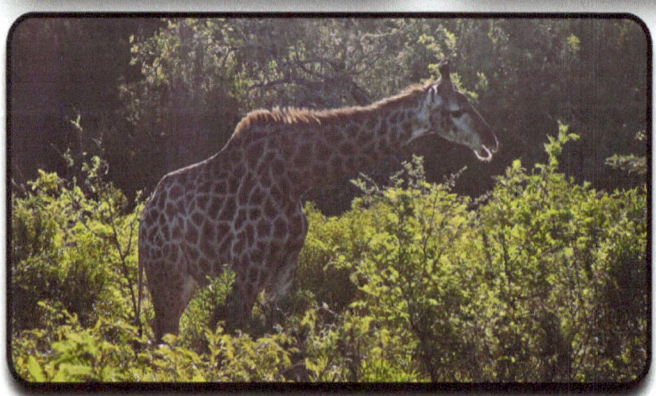
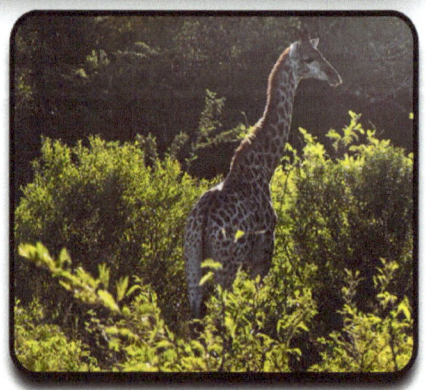

In Baswana's Chobe Park, this leopard has just taken down an impala for its afternoon meal. He will eat as much as he can now and come back and finish up the rest later if no one beats him to it.

A Beautiful impala. Impalas are the most populous animals in the park. He'll have to watch out for this female lion resting below in the shade.

One of the safest rides you can take in the middle of the forest is on the back of an elephant. Nobody messes with the elephant. They are like big tanks strolling through the forest. Actually its a very comfortable ride--like riding high on a rocking chair.

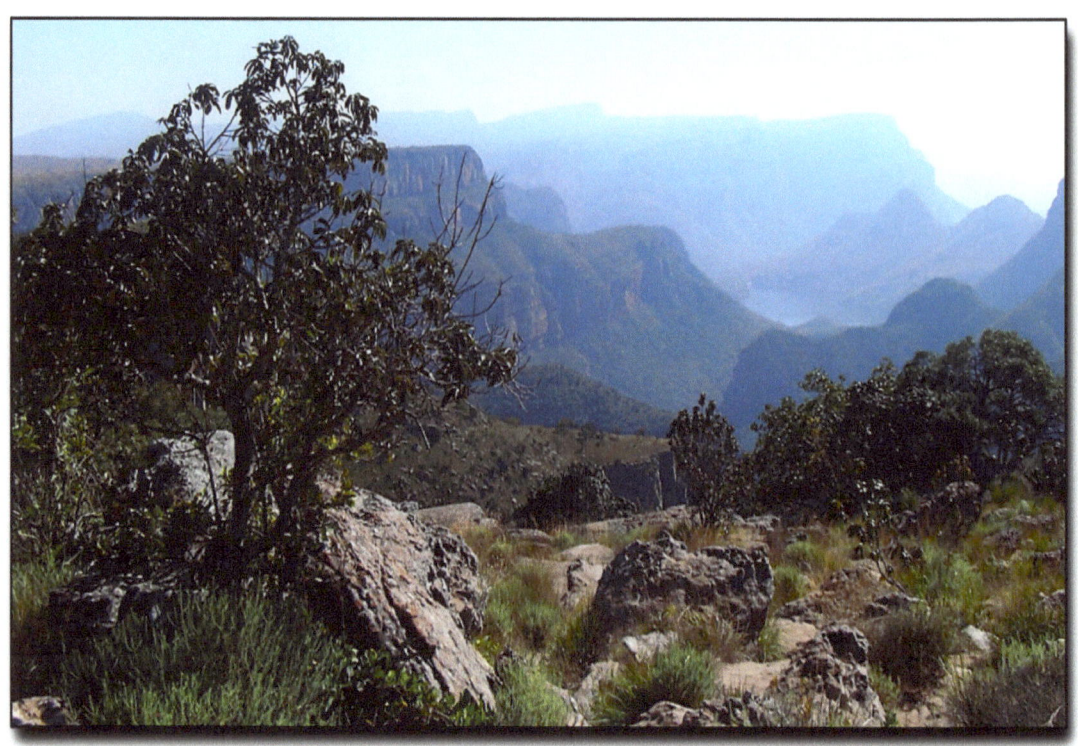

Blyde River Canyon is one of the largest canyons on Earth and most likely the greenest due to its lush subtropical foliage. The canyon is part a S.Africa Panorama route that also includes Bourke's Luck Potholes

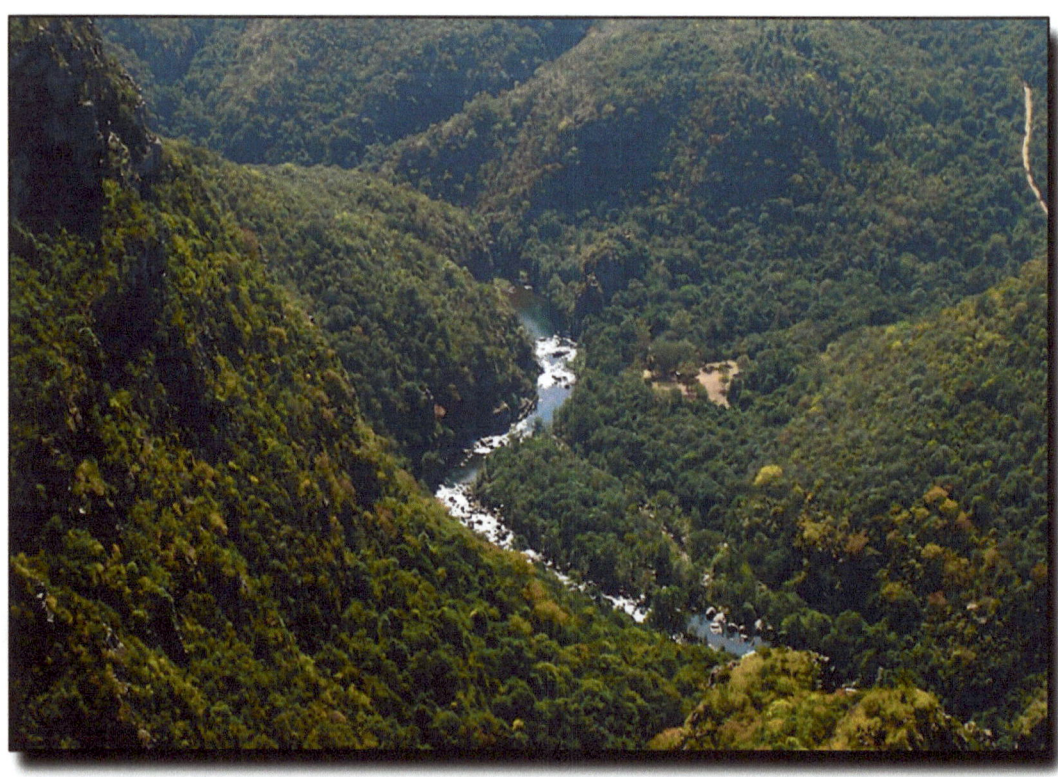

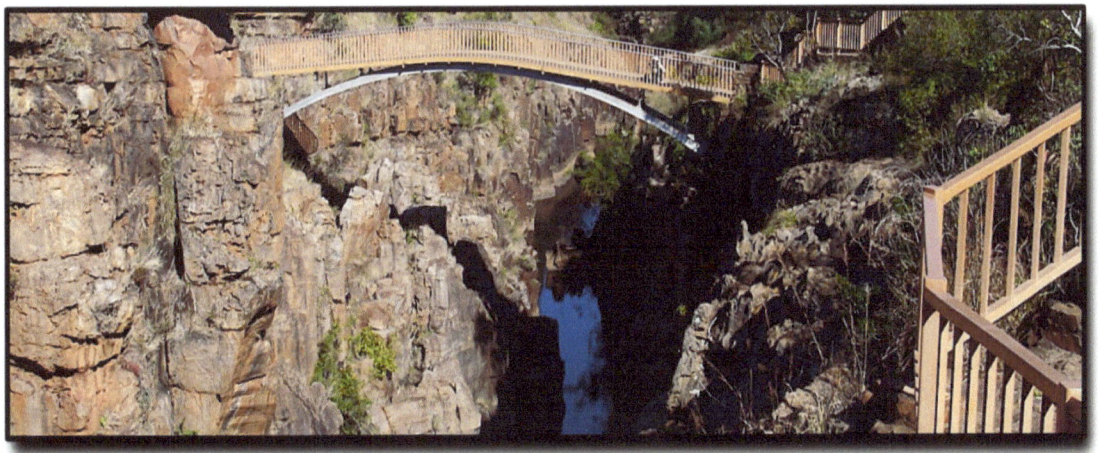
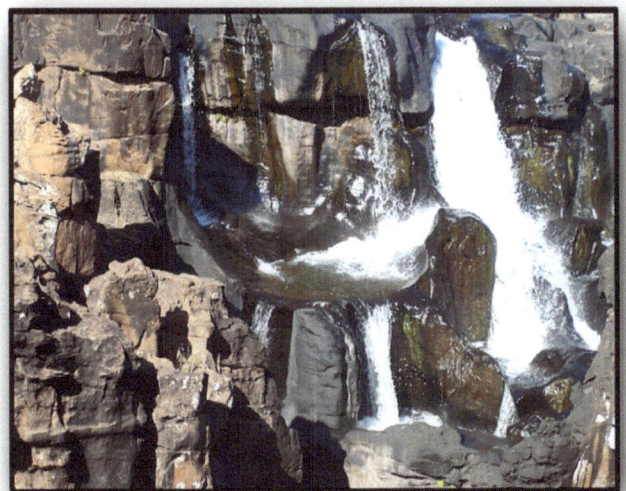
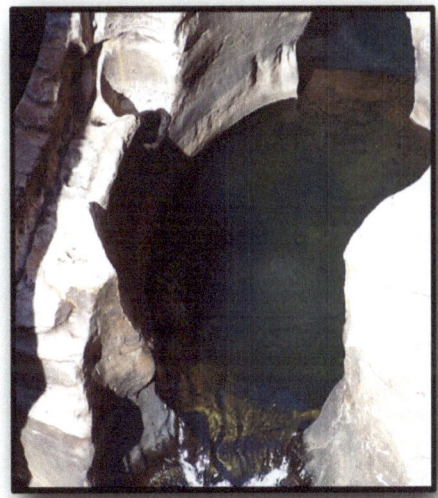
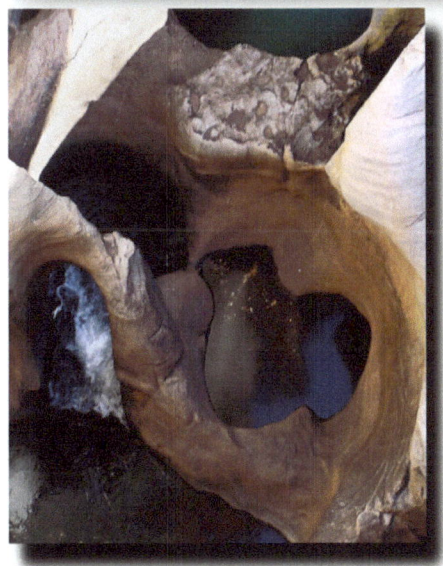
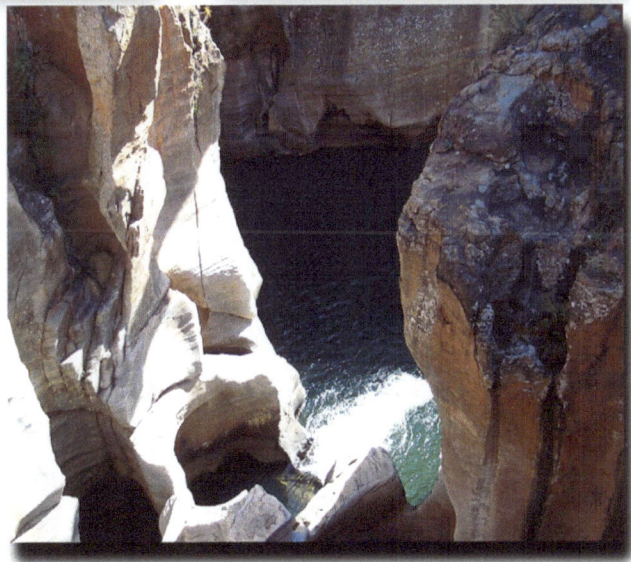

Bourke's luck Potholes were named after Tom Boourke a local prospector who predicted he would find gold here but had no luck. The potholes were formed by Blyde River colliding with Treur River going in a different direction. The swirling of the water over the limestone rocks made these beautiful potholes.

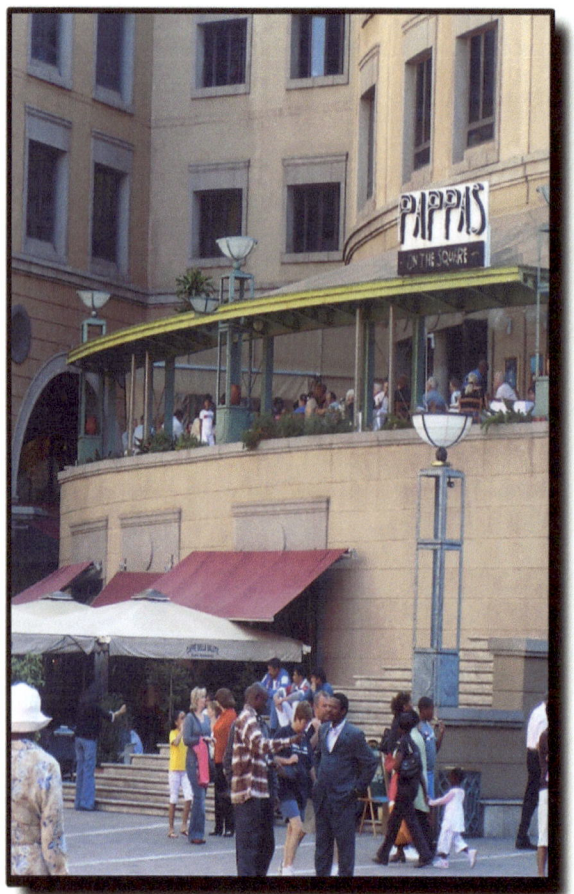
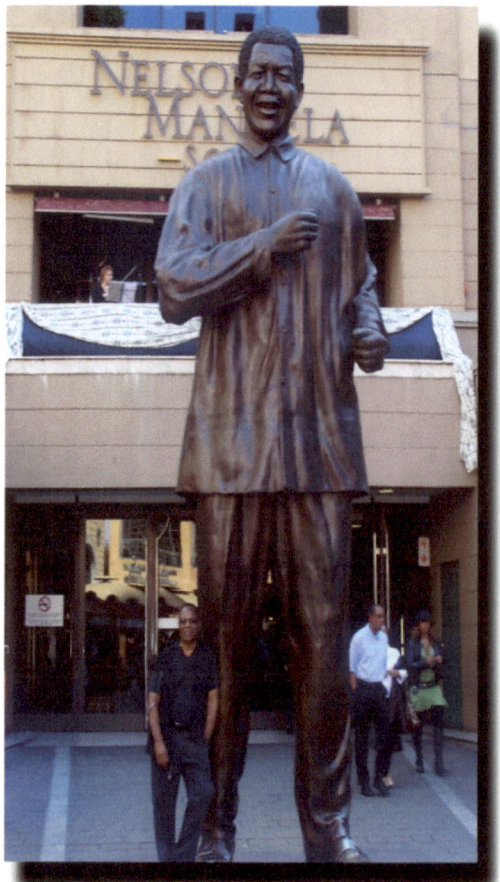
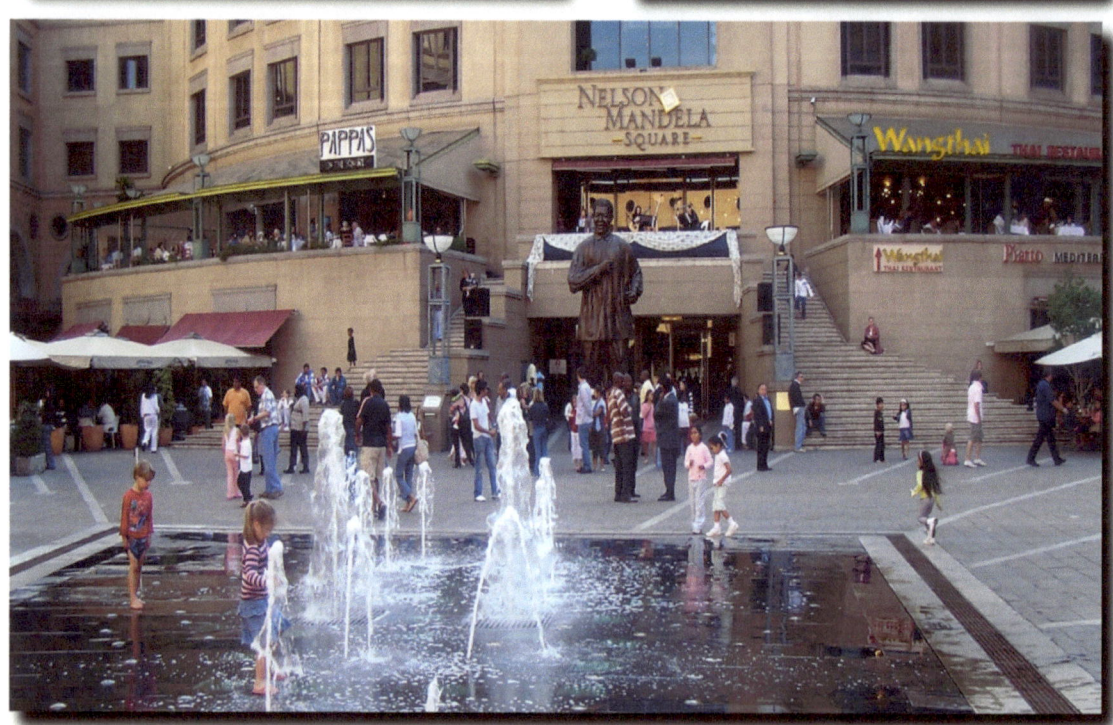

Johannesburg is also know as" The city of gold." Sandton Square in Sandton City, Johannesburg, is Africa's most prestigious and leading shopping centre. In contrast to the setting, it was renamed Nelson Mandela Square in March of 2004 to honour the former South African president.

This is Mandela Neighborhood in Soweto. His home is now a national monument attracting many visitors. The home of Windy, and that of Archbishop Desmond Tutu was right around the corner from his home.

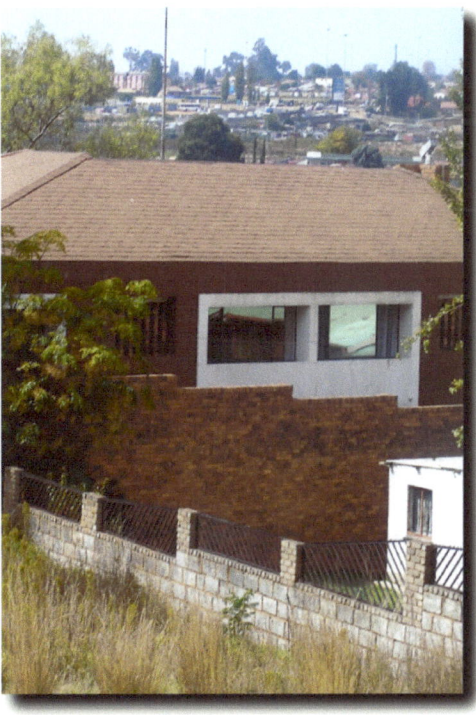

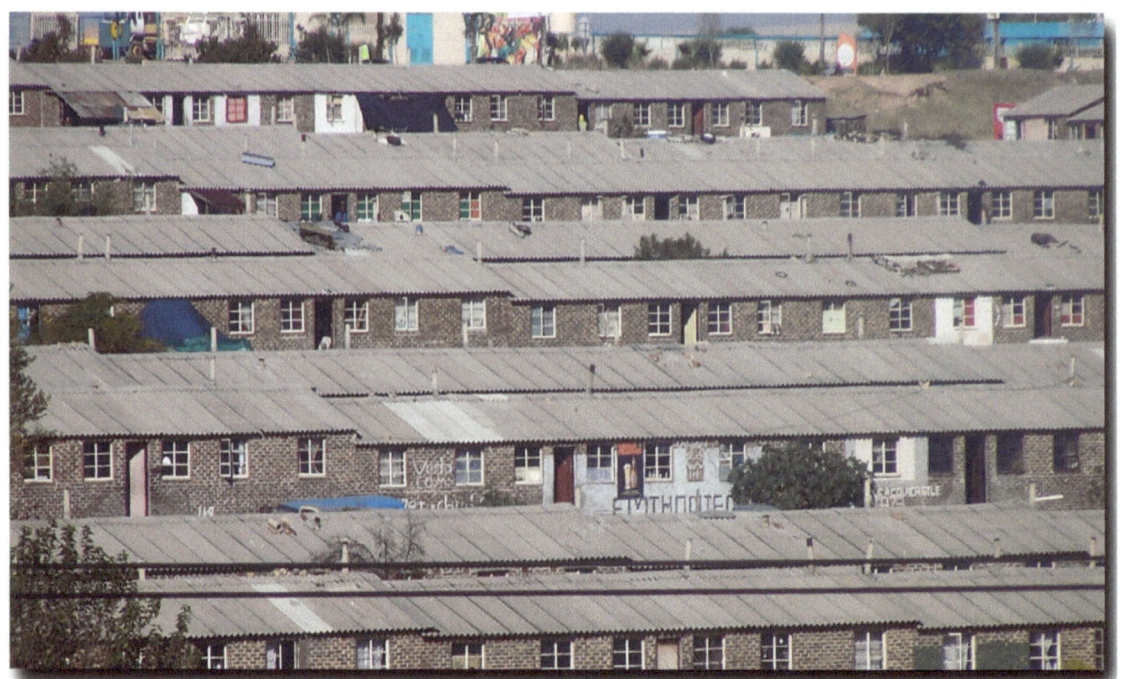

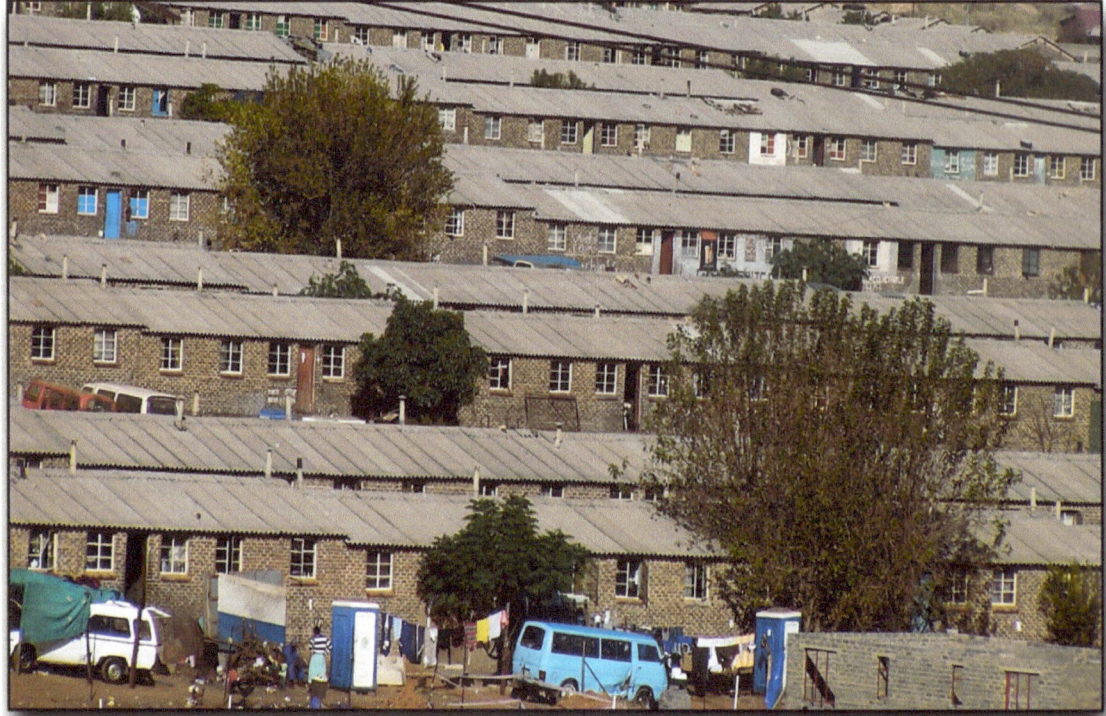

"Soweto" stands for South Western Townships and known for its mass structure of densely populated townships compiled to separate Blacks from Whites during during the hostile SA apartheid government rule. These one bedroom condominiums, many without running water and toilets other than outside port-a-potties, replaces many of the townships as a part of 1.5 Million rand reparations settlements resulting form law suits against multinational countries for their collaboration with South Africa's (1948-1993) apartheid government.

The Hector Pieterson Museum is an a apartheid museum. it includes a detailed history and exhibits of a painful period of time in S. Africa's history.

The photo on the monument is one of the most famous in the world. It's a photo of a boy carrying the body of 13-year-old Hector Pieterson. Hector was the first child to die in the 1979 Soweto Uprising against apartheid in which more than 1000 black children were killed across South Africa. After the photo appeared on the front page of the New York Times the movement gained international attention and support for the end of SA apartheid.

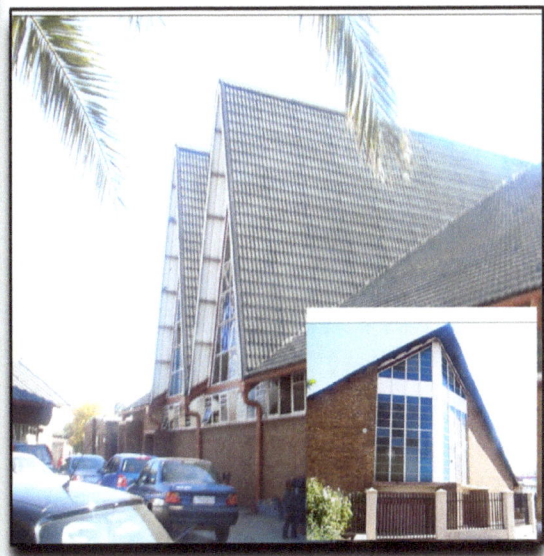

Soweto's community Regina Mundi Church played a crucial role in the struggle against apartheid as a sanctuary and meeting place for protesters.

The beautiful Victoria Falls: Referred to by the locals as "The smoke that thunders"

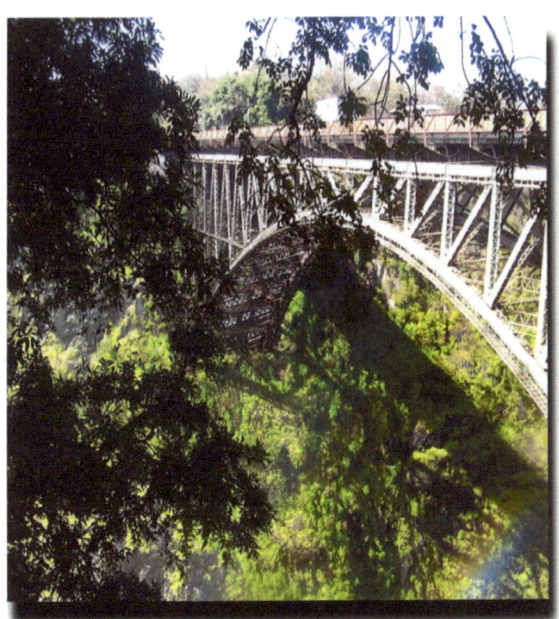
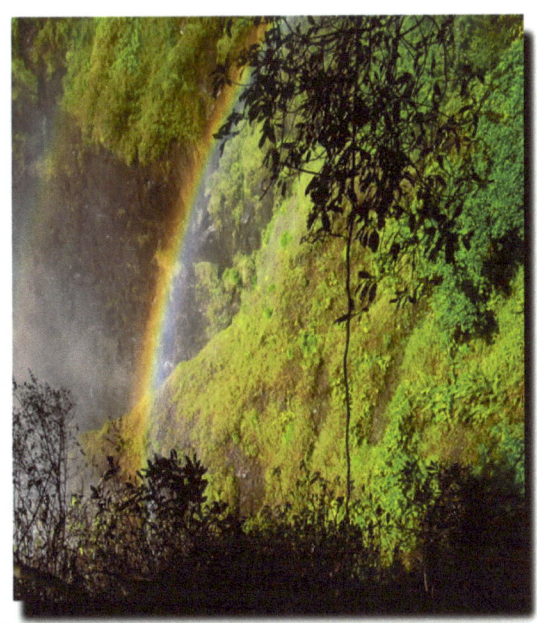

Victoria Falls is a waterfall in southern Africa on the Zambezi River at the border of Zambia and Zimbabwe. There is a bridge that crosses over the falls and splits the borders between Zambia and Zimbabwe. Access to the falls from either side, Zambia or Zimbabwe requires passports or visas to visit the falls.

While it is neither the highest nor the widest waterfall in the world, it is classified as the largest. Victoria Falls is roughly twice the height of North America's Niagara Falls and well over twice the width. Actually its about six falls in one created by gorges from the force of the falls.

Victoria Falls is considered one of the seven natural wonders of the world. David Livingston is credited for being the first European to view the falls.

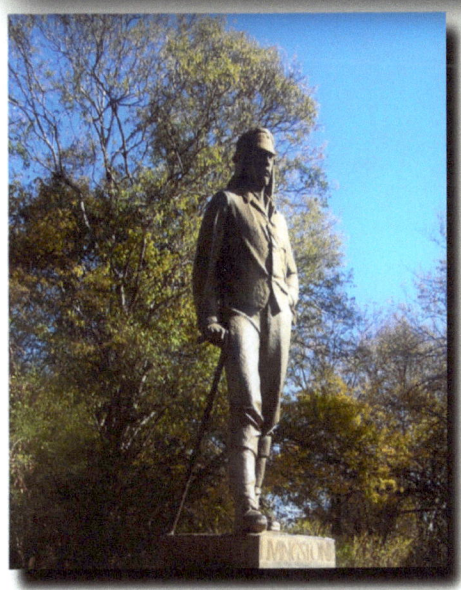
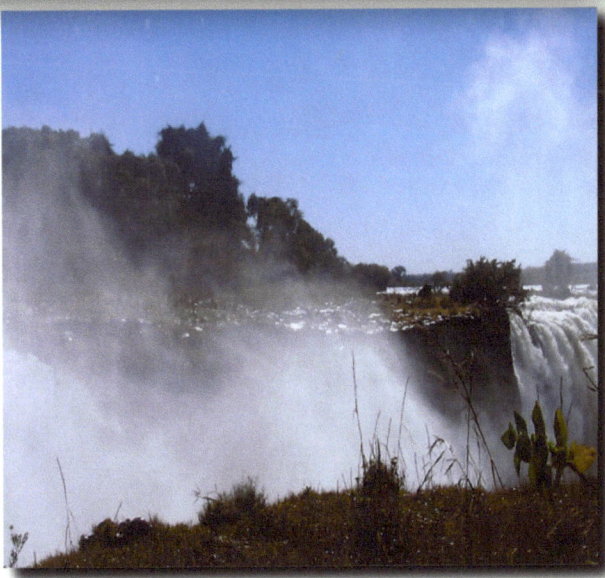

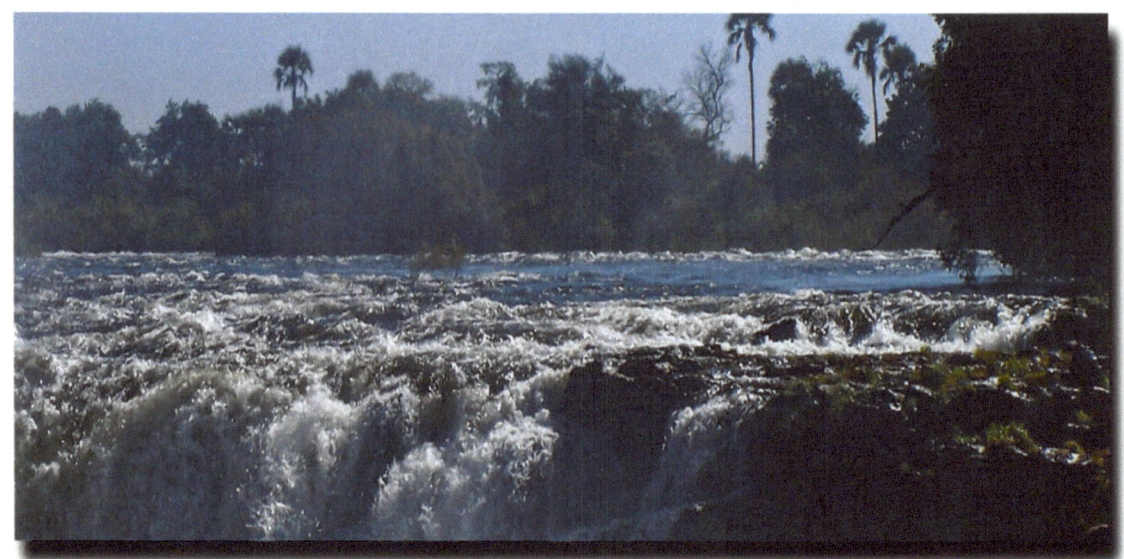
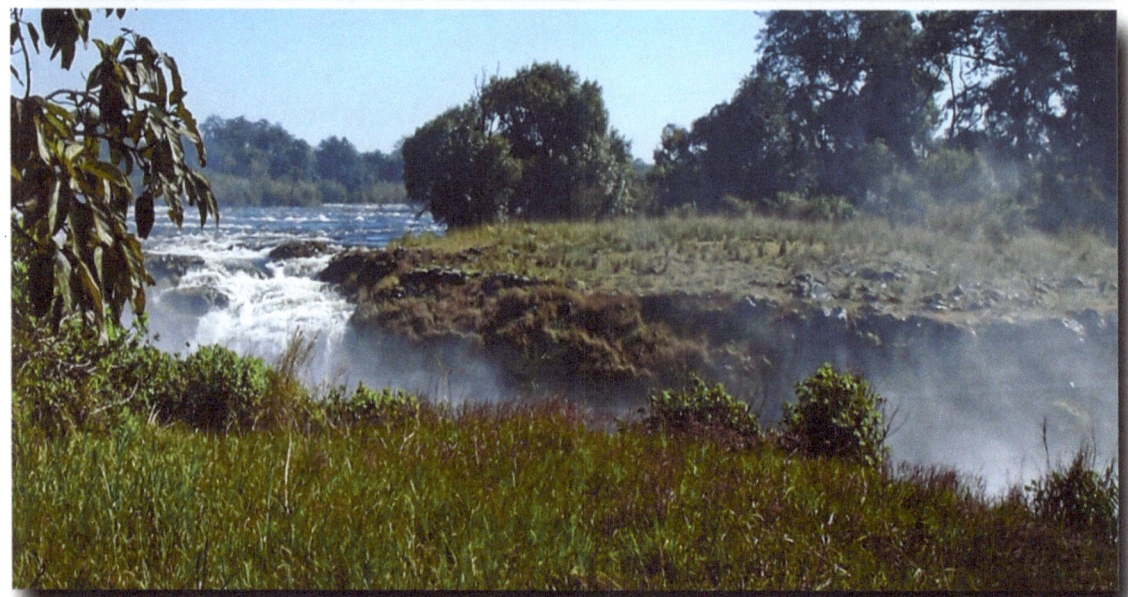
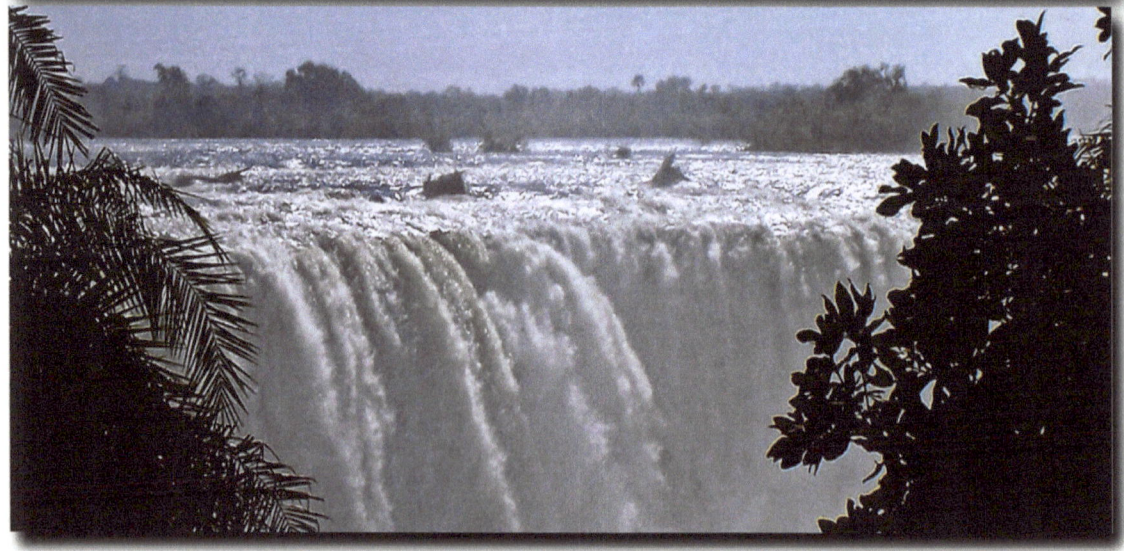

www.ingramcontent.com/pod-product-compliance
Lightning Source LLC
Chambersburg PA
CBHW040750200526
45159CB00025B/1834